AN ORGANIC HANDBOOK

Growing
Under Glass

without using chemicals

SUE STICKLAND

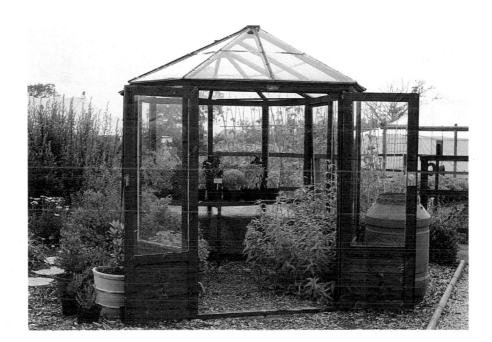

the organic
organisation

HDRA/Search Press

Published in Great Britain 2002

Search Press Ltd
Wellwood, North Farm Road,
Tunbridge Wells, Kent TN2 3DR

in association with

HDRA
Ryton Organic Gardens
Coventry CV8 3LG

Originally published in 1993 as *Greenhouses: natural vegetables, fruit and flowers all the year round*

Illustrations by Polly Pinder
Photographs by Charlotte de la Bédoyère

All the photographs in this book have been taken in organic greenhouses, and all the fruit, vegetables and flowers pictured have been grown organically.

The publishers would like to thank Horticultural Research International, Littlehampton, West Sussex, for permission to reproduce the photographs of *Encarsia formosa* (page 52), *Phytoseiulus persimilis* (page 54), *Aphidoletes* larva (page 50), insect-parasitic nematodes (page 55), sciarid fly (page 54), tomato moth caterpillar (page 53), vine weevil larva (page 55), and sooty mould (page 48).

ISBN 1 903975 43 3

Printed in Spain by Elkar S. Coop, 48180 Loiu (Bizkaia)

Conversion Chart

From centimetres to inches		From grammes to ounces	
1 cm	= ½ in	7g	= ¼ oz
2.5 cm	= 1 in	14g	= ½ oz
5 cm	= 2 in	28g	= 1 oz
10 cm	= 4 in	110g	= 4 oz
50 cm	= 20 in	450g	= 16 oz (1lb)
100 cm (1m)	= 40 in	*from litres to pints*	
1sq m	= 1.2 sq yds	1l	= 1.75 pt

Exact conversions from imperial to metric measures are not possible, so the metric measures have been rounded up.

Introduction

A greenhouse helps you to make the most of your garden, all the year round. With its protection, you can grow a wider range of flowers, fruit, and vegetables over a longer period. You can raise transplants for the garden, giving them a good start before they meet the harsher conditions outside. It also makes a sheltered retreat where you can enjoy working on cold, wet days.

Growing organically in a greenhouse means creating a place where plants will thrive – with no need for chemical sprays or artificial feeds. In many ways this is an easier task than it is outside: the greenhouse is a relatively small area, where you are more in control of the environment and less at the mercy of the weather.

However, good day-to-day management is essential for success – correct watering and adequate ventilation, for example. Also, plants must also be well fed. In an organic greenhouse, nutrients are mostly provided by the activities of micro-organisms, which break down organic matter in the soil or potting compost, rather than by liquid feeds. This is the best way to give plants a balanced diet.

The plants and growing schemes covered in this book are for greenhouses that have no routine heating or lighting except that which the sun provides. A heated propagator or minimal heating to cover extremes of the weather are useful extras, but do not try to push nature too far. As you will see, you can still enjoy an exciting range of crops and flowers every month of the year.

In fact, the greater the variety of plants there are in an organic greenhouse the better. Fruit and vegetable crops and flowering, foliage, and pot plants from different plant families and with different growth habits not only make the greenhouse more interesting and attractive, but also help to establish a natural balance where pests and diseases are less likely to get out of hand. Some flowers will attract predatory insects into the greenhouse, helping to keep pests under control.

Good management, soil care and judicious choice of plants will all help to prevent problems in the greenhouse. However, you should still keep a close watch for signs of trouble. The last part of this book will help you to identify common greenhouse pests, diseases, and other problems. It also suggests specific ways of controlling them and, equally important, of avoiding them in the future.

Choosing, siting, and planning a greenhouse

The type of greenhouse that you choose and the site that you select for it are both vital factors in providing a good environment for your plants. Of course, not everybody has the chance to buy the perfect greenhouse, or has the ideal place to put it. However, there are often adaptations that can be made, such as putting up wind-breaks, installing extra vents and insulation, or making benching that folds away. Most important, with careful planning you can make sure that the plants you grow are suitable for your greenhouse, whatever its shortcomings. If you are just starting out, then check the chart below.

What will you use your greenhouse for?

Use	Requirements and conditions
Raising annual plants for the garden	Good light early in the year. Benching with sand and capillary matting (you can get foldaway benching if you need the space later). A heated propagator is a great advantage.
Raising other plants from seeds and cuttings	Benching, as above. Shade in summer. A heated propagator will give you better results with a wider range of plants.
Growing tender summer vegetables, such as tomatoes	Soil borders are preferable. Good ventilation and light, and an efficient means of watering. A greenhouse with high eaves and glass to the ground is preferable.
Growing winter vegetables	Soil borders are preferable. Good insulation. During cold months of the year, some crops can be forced if placed under benching.
Growing fruit	Tree fruits usually need plenty of space and are difficult to fit into a small greenhouse with other plants. Growing trees in pots and moving them outside in summer is a possibility, but you will need a greenhouse with good access and a wide door. A vine is easier to accommodate (although it needs rigorous training), as are strawberries and melons. All need good light and ventilation.
Growing houseplants	Heat in winter is needed for many, but not all, common houseplants. Shading and sometimes humidity in summer.
Producing cut flowers, such as chrysanthemums	Chrysanthemums fit into a mixed greenhouse if grown in pots. Hardy annual flowers are best in soil borders. All need good light. Insulation extends the season.
Growing ornamentals for flowering in the greenhouse	You can find ornamentals to fit most greenhouses and cropping plans (see pages 42-7) although only foliage plants will grow in very shady conditions.

Choosing a site

To be of most use, a greenhouse needs to be in a position where certain conditions prevail.

• **Plenty of light** This is needed for as much of the day as possible, especially in winter. To get the best light, site the greenhouse away from buildings and trees. Remember, shadows will be much longer in winter than in summer. If possible, align a traditional barn-shaped greenhouse with its ridge running east–west.

The east–west orientation of this greenhouse lets in most light in winter because it minimizes shading by the greenhouse structure. In this position, the angle of the glass presented to the sun is the best for light penetration.

A north-facing lean-to is best kept for decorative foliage and other shade-loving plants in summer.
Greenhouses on east- and west-facing walls will grow a wide range of plants. A west-facing one gives the warmest overnight conditions, whilst an east-facing lean-to heats up most quickly in the morning.
A lean-to greenhouse on a south-facing wall will get most sunshine, but will need good ventilation and shading in summer.

• **Shelter from strong winds** Trees and hedges which are far enough away not to cause undue shading can still provide useful shelter from strong winds, which cause loss of heat as well as physical damage.

• **A free flow of air** For example, do not choose the bottom of a slope, as cold air drains downwards and forms a frost pocket where icy air collects.

• **Good drainage** If plants are to be grown in the soil borders, then choose ground that is well drained, otherwise you may need to install drains.

• **Good soil** At least one border of reasonably fertile soil is preferable if you want to grow cropping plants.

• **Mains services** Easy access to piped water makes watering more convenient. Electricity, although not essential for heating, is useful.

• **Easy access to the house** The easier it is to get to the greenhouse, the more care plants are likely to get. A lean-to greenhouse on a house wall has an obvious advantage regarding access. It will also stay warmer, because one wall is brick (which retains heat) and it will benefit from the heat escaping from the house.

• **Easy access** You will need to be able to get to the greenhouse with a wheelbarrow for carrying soil, compost, and large pots.

• **Space outside** This is useful for standing plants in pots and, possibly, for cold frames.

Choosing a greenhouse

Greenhouses differ not only in shape and size, but also in the materials used for their construction. The various options all have advantages and disadvantages, and some of these are looked at here.

The framework

Aluminium
Greenhouses with an aluminium framework are relatively cheap and need very little maintenance. They let in more light and lose more heat than wooden ones, although in most amateur greenhouses you will be unlikely to notice much difference. The variation in price between the same-sized greenhouse from different manufacturers usually reflects how sturdily they are made, i.e. how much material is in the framework and the method used to fix the glass.

Wood

Many people prefer the appearance of wooden greenhouses. They can be made of cedar wood, which is expensive but naturally durable, or cheaper but less durable woods such as teak. Cedar wood can last up to fifty years without any chemical treatment, but other woods should be pressure-treated with wood preservatives by the manufacturers, and will need further regular treatment to prevent rotting.

The manufacturers should also be able to tell you whether the wood comes from sustainably managed plantations. Cedar, for example, takes from seventy to ninety years to grow, and conservation groups claim that the timber used at present is destroying natural forests.

You may find that timber frameworks are more difficult to keep scrupulously clean.

UPVC

UPVC (a type of plastic) is used for the framework of some modern greenhouses and conservatories. It is durable and relatively maintenance-free. However, structures made from this material often need double glazing and a polycarbonate roof to give them sufficient strength. This makes them well insulated, but expensive.

The glazing

Glass

Glass is more durable and attractive than the plastics used to clad greenhouses. It provides much better conditions for plants: it lets through more light, traps the heat more effectively, and gives fewer problems with condensation. Also, it is easier to clean.

Horticultural glass is thinner and less expensive than ordinary glass; however, any glass is easily broken or cracked accidentally, and panes must be replaced quickly.

Plastics

Plastics are lightweight and easy to handle, but tend to discolour or become scratched, which can cut down on the amount of light transmitted.

Polycarbonate

Rigid plastic-like polycarbonate is very strong and durable and is often used for roofing greenhouses where glass would be too vulnerable. It is manufactured as a double- or triple-walled sheet, which gives it good insulating properties. However, it is more expensive than glass and has only about 70–80 per cent of the light transmission.

Checklist for choosing a greenhouse

Is it sturdy?
This partly depends upon the amount of material in the framework. Look for diagonal 'wind braces' across the frame which give it extra strength.

Is it draught-proof?
Sections of the frame should fit snugly together with no gaps, and the door should fit tightly. Greenhouses glazed with bars which hold the whole length of the glass are usually the most airtight.

Is it high enough?
The height to the eaves is important for tall crops such as tomatoes. The ideal ridge height depends upon how tall you are. Make sure that you feel comfortable standing up.

Does the roof slope steeply?
A steep slope will shed any fallen debris or snow.

How many vents has it got?
The ventilation is inadequate in many greenhouses on the market. A greenhouse 180 x 240cm in size should have at least two vents, and the number should increase proportionately for larger structures. Check if extra louvre vents can be fitted.

Are gutters and drain-pipes included?
Catching rain in a water-butt conserves water and prevents waterlogging.

Are the doors and windows wide enough?
Check also that they are in the right place to suit your needs and the positioning of the greenhouse. You should be able to get in easily with a wheelbarrow and large pots.

Shape and size

A traditional barn-shaped greenhouse with straight sides and a rectangular base 1.8 x 2.4m, 2.4 x 3m, or 3 x 3.7m is the most popular. It will grow a wide range of plants successfully, and you will almost certainly find that you can fill the biggest that your site and pocket will allow.

A greenhouse with sloping or curved sides can be more stable on windy sites. Also, it lets in more light and heat because of the angle the glass presents to the sun – a distinct advantage for winter crops and plant raising in spring. Sides which slope very steeply, as in a dome-shaped greenhouse, can be a nuisance if you are growing tall crops.

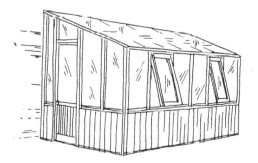

A lean-to greenhouse is the easiest to keep warm. The wall can be used to train fruit or climbing plants.

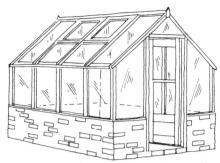

A timber or brick-wall base was traditionally used for a 'plant house' containing pot plants on staging. The walls help to conserve heat but block out the light, so they are less suitable where plants are grown in the borders. Some wooden greenhouses have removable panels around the base which you can slot in and out as convenient.

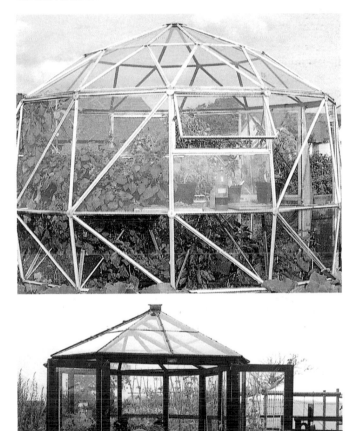

Circular or hexagonal greenhouses are attractive and provide a large useful growing area.

Planning a greenhouse

Even a small unheated garden greenhouse can be put to good use all the year round. If you plan carefully, then you can have different flowers in bloom and different crops to harvest nearly every month from January to December.

Creating the right environment

Temperature, moisture at the roots, humidity, shelter, light intensity, and day length all combine to affect plant growth. In a greenhouse you can manipulate these factors to grow a wide range of plants, some from climates quite different from your own, but you must find out what each plant needs in order to thrive.

A greenhouse is useful for growing plants that simply find it too cold in the garden. For example, cucumbers and peppers growing outside may produce summer crops, but in cooler climates it is not hot enough for long enough for them to give a really worthwhile crop.

The greenhouse can be used similarly to advance or extend the season of hardy crops and flowers, or to provide shelter for blooms that come naturally in the short days of winter, such as late-flowering chrysanthemums. A greenhouse also keeps off the rain, so giving a chance to plants such as alpines that tolerate cold but not damp conditions.

Growing a mixed collection of plants means that you have to cater for their differing needs, but if you water carefully and make use of the different 'climates' in the greenhouse – for example, the shady spots under the benching or draughty spots near the door – then there is no reason why they should not grow well together. The advantage is that different plants often have their own individual pests and diseases, so there is less chance of any one of them building up to an epidemic. You can also help to minimize this by planning a crop rotation (see page 49).

Making the best use of the greenhouse

The space in a greenhouse is valuable, so try to make use of it at all levels, for example, by putting shade-loving plants under the staging or, perhaps, half-hardy flowers in hanging baskets.

Try also to make use of your greenhouse at all times. Most plants only need greenhouse protection for a few months of the year. At other times they might be put outside in pots or stored as dormant bulbs, and some will take only weeks to grow from seed. Thus, you could grow tender shrubs in large pots, so they can be moved outside in summer to make way for tender annuals. Bring on summer-sown crops like lettuce, parsley, and other salads in modules outside to fill the greenhouse border when tomatoes and cucumbers are over. Keep a diary of sowing, harvesting, and clearing dates to help you in the future.

This plan shows how a typical barn-shaped 3 x 2.4m greenhouse can be arranged to make the best use of space.
P = Covered propagator with soil-warming cables (not shown).
V = Vine trained up and then along the ridge.
S1, S2 = Staging with sand trays.
U = Space under benches.
B1, B2 = Borders (soil).
H = Space for large pots in semi-shade.

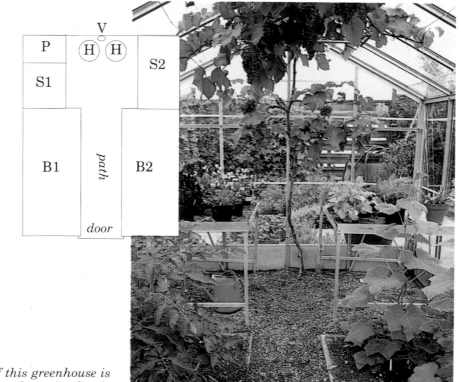

The layout of this greenhouse is similar to that shown in the plan.

Growing calendar

This calendar shows how you might fill a small garden greenhouse throughout
the year, to make it both attractive and productive.

SPRING

PROPAGATOR Seedlings of half-hardy vegetables for the greenhouse, e.g. tomatoes;
vegetables for the garden, e.g. celery; half-hardy flowers for the greenhouse and for
bedding out.

STAGING Spring bulbs, e.g. **daffodils**; winter bedding plants, e.g. **dwarf wallflowers**
(*Cheiranthus*) in pots; early transplants for the garden, e.g. broad beans, lettuce; pots
of hardy herbs, e.g. **chives** (*Allium schoenoprasum*).

SPACE UNDER BENCHES Foliage plants, e.g. ivies; forced vegetables from the garden, e.g.
Witloof chicory; shrubs in pots that have finished flowering (see winter).

SOIL BORDERS Last of the winter salads, e.g. **endives, Chinese mustards, seedling
crops** (see winter); hardy annual flowers, e.g. **pot marigolds** (*Calendula officinalis*);
early vegetables, e.g. carrots, **radishes**, cutting lettuce.

SPACE FOR LARGE POTS Half-hardy perennials, e.g. bay (*Laurus nobilis*), lemon verbena
(*Aloysia triphylla*).

SUMMER

PROPAGATOR Softwood/semi-ripe cuttings (shade if necessary).

STAGING Half-hardy vegetables in pots, e.g. peppers, aubergines; wallflowers; half-
hardy perennial flowers (overwintered in greenhouse), e.g. **geraniums** (*Pelargonium*),
fuchsias; half-hardy annuals in pots, e.g. **verbena, petunias**; summer bulbs potted up.

SPACE UNDER BENCHES Foliage plants; shade-loving half-hardy annuals; shrubs put
outside in a sheltered part of garden.

SOIL BORDERS Tomatoes, edged with half-hardy annual flowers and herbs, e.g. French
marigolds (*Tagetes patula*), bush basil (*Ocimum minimum*); cucumbers; climbing half-
hardy flowers, e.g. morning glory (*Ipomoea* syn. *Convolvulus* spp.); early vegetables,
e.g. **lettuce, carrots**.

SPACE FOR LARGE POTS Half-hardy perennials moved outside.

AUTUMN

PROPAGATOR Semi-ripe cuttings.

STAGING Winter salads in modules for planting into beds when summer crops have
been removed; **half-hardy vegetables** (see summer); **perennial flowers** (as summer);
summer bulbs, e.g. **nerines**; wallflowers potted up for spring flowering.

SPACE UNDER BENCHES Foliage plants (as summer); early flowering shrubs brought in.

SOIL BORDERS **Tomatoes** and **edging** (as summer); **cucumbers** and **climbers** (as summer).

SPACE FOR LARGE POTS Clumps of hardy herbs potted up; half-hardy perennials brought
in for protection.

WINTER

PROPAGATOR Overwintering small tender plants, e.g. newly rooted geranium cuttings.

STAGING Pots of hardy herbs, wallflowers, and spring bulbs; forced bulbs for winter
flowering, e.g. **'Paper White' narcissi**; early flowering shrubs, e.g. camellias.

SPACE UNDER BENCHES Hardy foliage plants.

SOIL BORDERS **Winter salads** (see spring); **winter lettuce**; **seedling crops**.

SPACE FOR LARGE POTS Half-hardy perennials.

(**Bold type** indicates crops ready to harvest and flowers in bloom.)

Managing a greenhouse

Maintaining the right environment in the greenhouse involves a range of factors: watering, ventilation, shading, heating, and good hygiene.

Watering

Getting this right is important. If plants have too little water, then they become stressed and are more prone to pests and diseases. If they have too much, then they are liable to attack by a variety of fungal diseases.

When to water

Unfortunately, there is no easy formula for deciding when to water. Different plants have different needs, which also depend upon the time of year, the weather, and the growing medium. Plants in pots will need watering much more than those in the greenhouse border.

In general, plants need most water when they are growing quickly, especially on sunny, windy days, and least water when they are growing slowly, especially on cold, dull days. The following suggestions will help you to judge when to water.

• Scratch the surface of the soil, or of the compost in pots, to test whether it feels dry.

• Observe the colour of the soil or compost. Dry soil or compost is lighter in colour than that which is moist.

• Lift up pots. Dry pots feel lighter than moist ones.

• Watch for signs of wilting. Leaves will often look dull and slightly droopy before the plant wilts.

• Try to avoid watering when it is cold and damp, or late in the evening when a cold night is expected, as this will encourage fungal diseases and slugs.

How to water

Water plants in a greenhouse border as you would in the garden. A mulch of organic material, such as leaf mould, lawn mowings, or compost, will help to retain moisture and protect the soil surface from the impact of heavy watering. Some materials can also help to feed the plants (see pages 16–17).

Water plants in pots until the compost is soaked, but stop before the water streams out of the bottom of the pot. If they have become so dry that water is not absorbed, then stand them in a deep tray of water and let it soak upwards. This is also a good way to water trays of seeds and seedlings (see page 28). In summer, put plants on trays of moist sand or special capillary matting material to help conserve moisture and raise humidity.

On dull cold days, water carefully using a watering can without a rose. Try to avoid splashing water on plant leaves or around the greenhouse, because dampness in these conditions can cause fungal diseases. On very hot days in summer, however, it is often beneficial to spray the plants and greenhouse floor with water. This cools the greenhouse and creates humidity, which helps reduce the need for watering. It can also help to control attacks of red spider mite (see page 53–4).

Avoid spraying delicate plants and seedlings in bright sunshine, as water droplets on plant leaves focus the sun's rays and cause scorching.

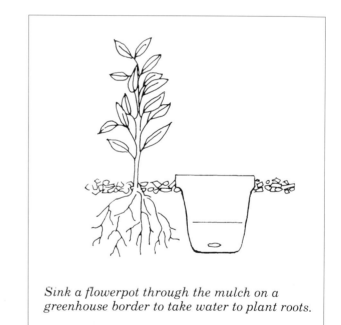

Sink a flowerpot through the mulch on a greenhouse border to take water to plant roots.

Equipment

• A good watering-can, i.e. one with a long spout and a removable fine rose that does not dribble. Fill the can and leave it in the greenhouse so that the water has a chance to warm up before you water tender plants.

• Water-butts for collecting rain help to conserve water resources. Provided that the butts have tight-

fitting lids to keep out debris and insects, the water should be clean enough to use for established plants, but it will inevitably contain some bacteria and fungi. It is better to water seeds, seedlings, and cuttings with fresh tap-water to minimize the risk of fungal disease.

• A hose connected to the mains supply will be needed, as water-butts and watering-cans are unlikely to supply sufficient water in summer.

• You can also buy a variety of more sophisticated watering systems, which make the job easier and less time-consuming. Devices such as sensors, timers, and reservoirs mean that, in theory, you can leave the greenhouse to water itself. However, it never hurts to check it. Few automatic devices are as good as an experienced greenhouse gardener!

A wooden water-butt.

Watering systems
1. A sprinkler is good for watering trays of seedlings and lots of small pots. However, it has limited use in a small mixed greenhouse because it delivers the same amount of water over a fairly wide area, which may contain plants with differing needs. Also, it wets the plant foliage constantly, which can cause fungal diseases.

2. A drip system is good for individual pots, trays, and even hanging baskets.

3. A seep hose for plants in borders is more economical on water and does not create humidity.

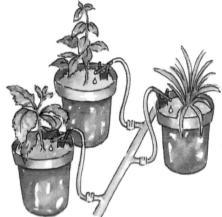

1.

2.

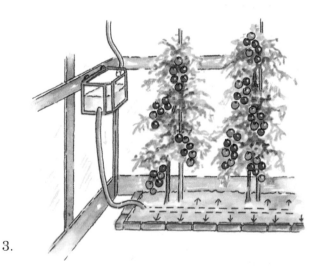

3.

Ventilation

Good ventilation is essential for keeping the temperature in the greenhouse down. Most plants that will grow in an unheated greenhouse prefer temperatures below about 28°C, although short periods of higher temperatures will not harm them. Fungal diseases are encouraged by stale air, and ventilation will help prevent their spread. Whenever the weather permits, open the greenhouse vents a little for at least part of the day, even in winter when cooling is not necessary.

Equipment

• Louvre vents, which most greenhouse manufacturers will supply as an extra, can replace any of the lower panes of glass and allow good air circulation. Many greenhouses on the market have too few vents and rely upon the door to provide ventilation.

• An automatic opener on a roof vent is a worthwhile investment for the summer, especially if you are away from home during the day. These respond quickly to temperature changes, and are easy to buy and fit. Make sure that the type you buy will open the vent wide and can be adjusted to start opening over a range of temperatures. Most will not open at low enough temperatures to allow ventilation in winter; instead, you have to put back the manual catch or use the other vents.

Shading

In summer, despite good ventilation, too much sun can overheat a greenhouse, and this is when shading is necessary. Give priority to shading the south and west sides of the greenhouse.

Equipment

• The outside of the greenhouse can be coated with a white shading paint. Traditionally, this was made from a stiff mixture of garden lime and water. Modern alternatives use chemical compounds, such as titanium dioxide, which stick well to the glass in rain yet wipe off easily with a dry rag. Shading paints are cheap, easy to apply, and effective. How-

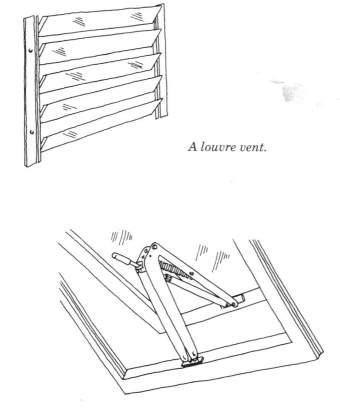

A louvre vent.

An automatic opener for a vent.

Shading paint applied to a small greenhouse helps to prevent overheating in hot weather.

ever, once they are on they stay on all season, so wait until light levels are generally high (around late spring) before applying them and wipe them off in early autumn.

• An alternative is to fix shading material on to the outside of the greenhouse for a similar time (shading on the inside, although cutting out the sunlight and preventing scorching, does little to reduce the temperature). Exterior blinds, which you can roll up on dull days to let in more light, are ideal but expensive.

In winter and early spring, plants need all the light that they can get, but you can provide temporary shade for seedlings and vulnerable plants by covering them with white paper, an old net curtain, or horticultural fleece.

Heating and insulation

Unlike artificial forms of heating, natural heat from the sun is not only environmentally friendly but also free! Make the most of it by doing all that you can to save heat.

Conserve heat

• Put up a fence or plant a hedge as a wind-break on exposed sites.

• Repair cracked panes of glass, and ill-fitting doors and vents, all of which lose heat; use draught-proofing strips if necessary.

• In winter, line the greenhouse with an insulating material to give a double glazing effect – this makes a tremendous difference to the amount of heat retained.

• Even if you want more general warmth, you do not have to heat the whole greenhouse. For example, use insulation material to screen off part of it for tender plants. Alternatively, cut off the roof space at night with a similar screen drawn over at the height of the eaves.

Extra heat

This book is intended to help you manage a greenhouse where artificial heating is not essential. Nevertheless, there are times when a little extra heat can be very helpful, for example, for raising plants earlier in the spring or for overwintering plants when weather conditions are extreme.

Wrap up your greenhouse for the winter

Bubble polythene is one of the best materials for greenhouse insulation. Buy the type that is designed for the purpose, not packing material as this deteriorates rapidly in the light.

• One disadvantage is that it will reduce the amount of light reaching the plants. To help counteract this effect, make sure that the greenhouse glass is clean.

• In a wooden greenhouse, secure the material with drawing or mapping pins. In an aluminium one, use special fittings which go into the channels in the framework, or use sticky pads.

• Make sure that the vents can be opened: it will be even more necessary to ventilate as the insulation will increase humidity. You may need to cut separate pieces of material and fix them independently to the vents. Cut a separate flap to hang down over sliding doors.

• In spring, the material filters the sunlight and acts as shading. However, it will do little to reduce the heat in the greenhouse in summer. It is better to replace it with a shading material or paint until the autumn. This also gives you the chance to wash the greenhouse thoroughly.

Wiring up your greenhouse

Electricity can be particularly dangerous in the damp greenhouse atmosphere. To be safe, always follow these safety rules:

• Fuse the greenhouse circuit separately, and incorporate a residual current device (RCD).

• Use waterproof plugs and fittings.

• Have the wiring installed by a professional electrician.

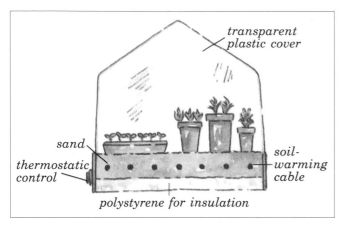

A propagator is useful for raising plants from seeds or cuttings, and for overwintering tender plants.

Equipment

• Hot benches or propagators which supply heat to the bottom of plant pots through electric soil-warming cables or a heated blanket use very little energy. They are a tremendous help in raising plants from seeds and cuttings, and if they are covered then you can also use them to help overwinter tender plants.

• The most common greenhouse heaters available are electric fans, electric tubes, bottled gas heaters, and paraffin heaters. A lean-to greenhouse on a house wall might have a radiator run from a central heating boiler.

• The problem with paraffin and gas heaters is that they produce water vapour, leading to high humidity and encouraging fungal diseases. Paraffin heaters may also produce small amounts of other gases which can damage some plants (see pages 61–2). To keep the humidity down, to let fumes out, and to let air in to the burners, you need to keep the greenhouse ventilated, and this wastes heat.

• Electric fan heaters, on the other hand, produce a dry heat. They circulate the warm air throughout the greenhouse and have accurate thermostats. Consequently, they only come on when absolutely necessary and are therefore less wasteful of energy than you might expect.

Alternative heat

The heat given off by decomposing organic matter was used in the 'hot beds' of Victorian kitchen gardens. The beds usually consisted of a layer of fresh strawy horse manure about 60cm deep, topped with about 20cm of soil, and were used, for example, to bring on cucumbers and melons.

The main problem with having any kind of hot bed or compost heap to provide heat in a greenhouse is that the ammonia given off in the decomposition process can be harmful to plants. The Victorians had one house entirely for cucumbers, which could be ventilated well for the first couple of weeks after the beds were made, before sowing or planting. In a greenhouse with a mixture of plants, the problem can be reduced by using alternate layers of manure and soil, or by mixing leaves or garden debris with the manure to absorb the ammonia. Alternatively, you could try using materials with less available nitrogen, such as a mixture of straw and kitchen waste.

In the USA, experiments to make use of the heat from compost heaps, or animal houses next to the greenhouse, have ducted the hot air through pipes below the greenhouse borders and up through leaf mould or soil to absorb harmful gases.

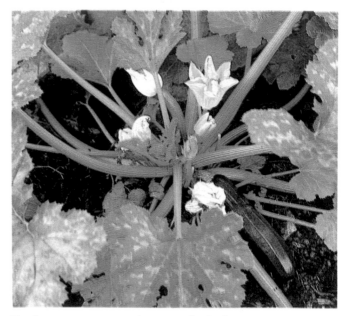

Early courgettes growing on a bed of manure.

Hygiene

• A good time to give the greenhouse a thorough clean is late autumn, when annual crops and flowers are over and you can catch pests and diseases before they overwinter. Choose a warm day so you can put pot plants outside temporarily. Thoroughly scrub the inside of the greenhouse structure: the framework, staging, and glass, with hot, soapy water.

• Good hygiene is the key to keeping plants healthy. Remember that in the warmer conditions in a greenhouse everything happens much more quickly than it does outside. Inspect your plants regularly. Remove diseased, dying, and dead leaves and flowers from plants. Discard dead or dying plants, seedlings, or cuttings. Look out for early signs of pests or diseases, and take appropriate actions (see pages 48–62).

• Change the sand in trays on the benches, and clean capillary matting. If you cannot work a proper rotation of crops (see page 49), or grow green manures (see page 18), then you may also need to change the border soil. Before returning your plants remember to examine each one carefully for signs of pests and diseases. Keep aside any that are not healthy for further treatment.

• Do not leave debris in the greenhouse. Dead plant material, dead plants, old composts, weeds, and dirty pots and trays are ideal breeding grounds for pests and diseases and should be removed.

• Clean the outside of the glass if it is dirty, as plants need all the light that they can get. Whilst outside, also empty and scrub water-butts.

Plant feeding

Plants in an organic garden obtain their food through the activities of soil organisms, which break down organic matter and release nutrients as plants need them. Ideally, the same should happen in a greenhouse, whether plants are growing in the border or in pots. Plants fed in this way are less likely to suffer nutrient overdoses or deficiencies, and generally will be much healthier.

Liquid feeds – even plant- or manure-based 'organic' ones – bypass the soil life and are easily washed out and wasted. They are no substitute for good preparation of the border soil or potting compost, and they should be used only to give a boost to plants when absolutely necessary.

However you do it, giving greenhouse plants a balanced diet is not easy. There are two main problems:

• **Shortage of nutrients** The plants often need more nutrients than they would outside because they are growing more quickly. This need has to be satisfied from a small volume of compost in a pot or from an intensively planted bed.

• **An excess of nutrients** Too high a concentration of nutrients results in various disorders. This is rarely troublesome outside, where rain continually washes out soluble salts, but it is a common greenhouse problem (see pages 59–61).

Tomatoes and lettuces growing in the soil of the greenhouse border.

Preparing greenhouse borders

It is preferable to grow crops in the greenhouse soil rather than in pots or growing bags. This gives them more root run and makes them easier to feed, provided that you give the soil the care and attention it needs.

Organic matter

This is essential, both to provide plant nutrients and to maintain the structure of the soil, which is at particular risk in a greenhouse from constant heavy watering in summer. Use compost, well-rotted manure, and other materials as appropriate to the crop, just as you would in the garden. They can be dug into the soil, or used as a mulch which will protect the soil surface and hold in moisture.

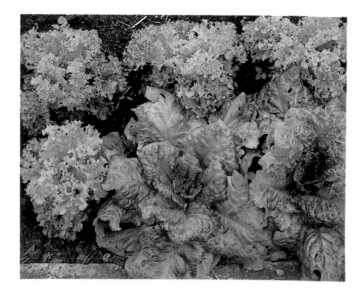

16

Organic matter for the greenhouse border

Well-rotted strawy manure

Use this to provide nutrients and improve the soil. Fork into the soil each season before planting hungry crops, such as tomatoes and cucumbers, and permanent fruit. Also, use it for mulching them when extra nutrients are needed. The recommended amount is about 5kg per sq m.

Garden compost

Use this in a similar way to well-rotted manure. As it is more stable and the nutrients less available, it can be used in greater quantities. It is also suitable for flowers, shrubs, and climbers.

Fresh strawy manure

Traditionally, this is used for hot beds (see page 14). If manure that is not well rotted is forked into the soil or used as a mulch, then there is a danger of:
• Burning plant roots.
• Ammonia gas building up in the greenhouse.
• Excess nutrients building up in the soil.
• Chemical residues from the straw affecting plant growth.

Leaf mould

Dig this into very light or heavy soils to improve the structure without adding nutrients (and hence building up the salt level). It is also useful as a mulch, especially on winter crops.

Grass mowings

Use a thin layer as a mulch (but beware of a build-up of ammonia, and ventilate if necessary). It adds nutrients to the soil as it breaks down.

Hay

Use this as a mulch around mature cropping plants.

Proprietary products

Bagged manures, composts, and soil conditioners often contain a bulky substance, such as peat substitutes, plus a source of nutrients. Follow the directions on the bag.

Green manures for the greenhouse

Plant	Botanical name	Sowing time	Weeks in ground	Hardiness
Buckwheat	Fagopyrum esculentum	Early spring to late summer	4 to 8	Susceptible to frost.
Fenugreek	Trigonella foenum graecum	Early spring to early autumn	4 to 8	Survives light frost: should survive over winter in unheated greenhouse in most areas.
Phacelia	Phacelia tanacetifolia	Early spring to early autumn	4 to 8	Survives light frost: should survive over winter in unheated greenhouse in most areas.
Mustard	Sinapsis alba	Late winter to mid-autumn	2 to 4	Survives light frost: should survive over winter in unheated greenhouse in most areas.
Winter tares	Vicia sativa	Early spring to early autumn	6 to 10	Hardy.
Grazing rye	Secale cereale	Mid to late autumn	2 to 4	Hardy.

Green manures

Green manures are crops grown not to eat, but to improve and protect the soil. The borders are usually full in spring and summer, but there is a good choice of green manures to fill a winter gap, e.g. winter tares (*Vicia sativa*) which fix nitrogen in the soil, and grazing rye (*Secale cereale*) which helps to mop up excess nutrients. Growing one of these is far better than leaving the soil to become dry and lifeless, and it will eventually provide organic matter when the crop is dug in or hoed off.

The chart above lists some of the green manures suitable for a greenhouse, and gives their hardiness, appropriate sowing times, and number of weeks needed in the ground to provide winter cover or enough growth to dig in.

Acidity and alkalinity

Use a pH testing kit to measure the acidity or alkalinity of the greenhouse soil at the beginning of the season, particularly if your plants have suffered from any deficiencies or disorders the previous summer. Most crops prefer a pH of about 6.5. Adding compost or manure to the border every year will gradually make the soil more acidic. Adding lime or calcified seaweed makes it more alkaline.

Organic fertilizers

On poor or overworked soils, addition of organic fertilizers such as hoof and horn or blood, fish and bone may be necessary. For further information on manures, compost, green manures, and organic fertilizers see the companion volumes in this series, *Soil Care and Management* by Jo Readman, and *How to make your Garden Fertile* by Pauline Pears.

Phacelia tanacetifolia.

Plants in pots

Growing mixtures for plants in pots are confusingly called 'composts', although they bear no relation to garden compost from a compost heap. These potting composts need special properties if they are to do their job well.

• They must hold water, yet also drain freely enough to allow air to reach the plant roots. This balance is provided by the spaces or 'pores' in the mixture.

• They must be stable enough to retain these pores even when they are packed into pots and continually watered from above.

• They must contain sufficient nutrients in a small volume to support plants over as long a period as possible. However, too many readily available nutrients can cause toxicities and imbalances, leading to deficiencies and disorders (see pages 59–62).

• Ideally, organic potting mixtures should be living mixtures, i.e. they should contain some form of composted organic matter which will supply the bacteria and fungi needed for the continual release of plant nutrients.

If you are buying a compost mixture, then check what it is meant to be used for. A 'potting' compost should contain more nutrients than a 'multi-purpose' compost, which is for both sowing and potting. 'Seed' composts contain few nutrients. You will need a potting compost to support cropping plants, such as tomatoes or fruit trees. The alternative is to make your own compost, bearing in mind the properties it needs.

Most successful mixtures contain a combination of one or more stable base materials, such as leaf mould, to provide the structure and hold air and

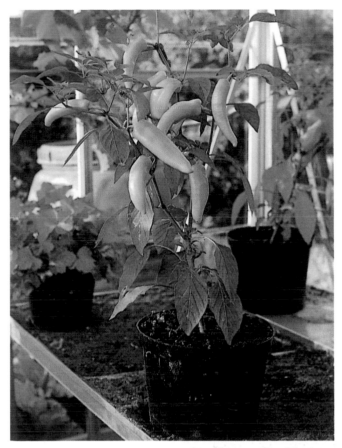

Hot pepper, Capsicum annuum*'Hungarian Hot Wax', and an ivy-leafed* Pelargonium *grow happily in pots.*

Polyanthus plants flower earlier in pots in the greenhouse.

Buying an organic potting compost

• Check whether it has the Soil Association (SA) symbol. The SA sets standards for organic production, and the symbol is a guarantee of the organic origins of the compost, but not necessarily of its efficiency.

• Look for a list of ingredients and compare it to the chart on page 21. Preferably, opt for a mixture that is peat-free but contains some form of composted organic matter. This could include such products as composted duck manure, brewery grain waste, or domestic refuse.

• Try it out on a small scale first.

water, plus nutrient-rich materials, such as worm compost, the main function of which is to provide plant foods. Materials commonly included in DIY potting mixtures are listed in the chart on the opposite page. Several mixture recipes are also given above, although these should be considered as a guideline only. Try your own variations to suit your particular ingredients, your plants, and your growing conditions. In particular, test the pH of any mixture containing new ingredients: aim for a value of about 6.0. Also, be aware that different mixtures may require different watering and feeding regimes.

Sterilizing soil for potting mixes

The aim is not to kill all life in the soil but to heat it to a sufficient temperature for long enough to kill harmful organisms and weed seeds. The temperature and time are quite critical. If you make a lot of your own soil-based compost, then you might consider buying a small steam sterilizer. A 10 litre bucketful of moist soil takes twenty-five minutes to sterilize. To sterilize small quantities of soil, the following methods have been suggested, although not scientifically tried and tested.

• **Electric or gas ovens** Place moist soil in a thin layer on a baking tray and cook for thirty minutes at 80°C (this is a smelly process!). It is easy to overbake it.

• **Microwave oven** Place moist soil in a large bowl, loosely covered. Heat on full power: 0.9kg for two and a half minutes, 4.5kg for seven minutes. Thoroughly clean the oven and door seal afterwards.

• **Saucepan** Pour 330ml water into a 3.5 litre saucepan. Heat and, immediately it boils, fill the saucepan with dry soil to within 2cm of the top; put on a lid and boil for seven minutes. Remove from heat, keep the lid on, and stand for seven minutes.

Whatever method you use, spread the soil out in a thin layer to cool as soon as the process is complete.

Storing organic composts

When potting mixtures containing organic matter or organic fertilizers are stored, the micro-organisms continue to work. In airless conditions, this can cause the build-up of substances that are toxic to plants. To avoid problems:

• Make up your own composts not more than two or three weeks in advance.

• Store them in a cool place.

• Ensure that the bag is not totally sealed.

• Air compost that has been stored for a month or more by spreading it out in a thin layer and leaving it for a day or two.

Other growing systems

Growing bags

Like pots, these give plants a limited root run and dry out very quickly. However, they can be extremely convenient. If you cannot buy organic growing bags, then you can make them yourself by filling a plastic sack with a potting compost mixture.

Ring culture

This is a system used commonly for tomatoes. They are grown in bottomless pots (rings) of potting compost sitting on a 15–20cm layer of clean gravel into which the plant roots grow. This avoids the problem of disease build-up in the soil and gives plants more root run to take up water.

Hot bed

This is a raised bed of manure and soil traditionally used for cucumbers and melons. It provides extra heat (see page 14) as well as plant foods.

Straw bales

Both tomatoes and cucumbers can be grown in straw bales which have been soaked with water and given a high nitrogen fertilizer to start them decomposing. If you try this method, then make sure that the straw you use has not been treated with a chemical weedkiller near to harvest, as this can harm your plants.

Potting-compost ingredients

Soil

This must be good fibrous soil, ideally made by stacking turf in a covered heap for a year. It provides some nutrients as well as structure. Sterilizing the soil will kill weed seeds and release nutrients.

Garden compost

This must be well rotted, dark, and crumbly. It is a good source of nutrients and also helps to hold air and water. It may contain weed seeds and disease organisms, although the risk is less if the compost comes from a heap that has heated up.

Worm compost

This has a high nutrient value and also a very stable structure. It is excellent for adding to a base material such as leaf mould. If you feed your worms only on kitchen scraps and vegetable peelings, then the compost should be free of weed seeds. (For details on making worm compost see the companion volume in this series, *How to make your Garden Fertile* by Pauline Pears).

Manures

Well-rotted strawy manure can also be used as a source of nutrients. It often needs chopping up and is best used in rough mixtures for large pots. It may contain weed seeds.

Peat

Peat forms the basis of most proprietary composts. It is a stable, sterile, consistent material, which is able to hold both air and water well and has little or no nutrient value. Also, it has a very low pH, so is suitable for acid-loving plants. However, it is not an easily renewable resource; it takes thousands of years to form and its extraction is threatening valuable wildlife habitats, so it is preferable to use a peat substitute.

Coir

Coir is a fibrous waste from the coconut industry, which is used as a peat substitute in some proprietary potting mixtures. It has good stability and holds water and air well. It has little nutrient value and a higher pH than peat. However, coir has to be shipped half-way across the world, so it is preferable to use 'home-grown' alternatives.

Leaf mould

This is a good home-made peat substitute. It is stable and holds air and water fairly well, although it tends to drain more quickly than peat. It has little nutrient value. For use in potting mixtures, it should be two to three years old so that it crumbles into smallish brown/black pieces. The older it is, the better it holds water.

Shredded bark

A percentage of fine grade bark (commonly up to 25 per cent) is used in some proprietary mixtures. Make sure that any bark you buy has been matured without added chemical nitrogen. It is useful for making mixtures more open, hence reducing waterlogging. It has little nutrient value and tends to deplete nitrogen. Therefore, initially, you may need to add more nitrogen to mixtures – either with organic fertilizers or increased amounts of manure or compost. There is some evidence that bark can suppress diseases such as damping off.

Comfrey

The leaves of Russian comfrey (*Symphytum* x *uplandicum*) can provide nutrients for potting mixtures. Incorporate it by mixing the chopped leaves with, for example, an equal volume of leaf mould and leaving the mixture in a plastic sack until the comfrey has decomposed.

ANALYSIS OF COMFREY

Nitrogen 3.5%, phosphorus 0.5%, potassium 5.9%.

Limestone, dolomite lime, and calcified seaweed

Any of these materials can be used to increase the pH of the mixture. Calcified seaweed also provides trace elements.

Organic fertilizers

Mixtures of fertilizers such as bone meal, seaweed meal, and hoof and horn can be used to boost the nutrient content.

ANALYSIS OF ORGANIC FERTILIZERS

Bone meal: nitrogen 3.5%, phosphorus 20%, potassium 3.1%.

Hoof and horn: nitrogen 13%, phosphorus 0%, potassium 0%.

Seaweed meal: nitrogen 2.8%, phosphorus 0.2%, potassium 3.1%.

Coarse sand or grit

Small amounts of these can be used to increase drainage. They are preferable to perlite or vermiculite, which take a lot of energy to manufacture and do not decompose quickly when discarded.

Feeding established plants

If borders and potting composts are well prepared, then additional feeding will be kept to a minimum. Ideally, annual plants in borders should not need any extra nutrients, but fruiting plants in pots and perennials will need feeding after a time.

There are no simple rules to tell you how much and when to feed, but, as a rough guide, annual fruiting plants such as tomatoes and peppers are most likely to need feeding from the time that they start to flower and form fruit up until their growth slows down at the end of the season. Perennial plants are most likely to need feeding when they are making most growth, i.e. in spring (unless they have been repotted) and in summer. You can supply additional plant foods by the following methods.

• **Adding organic fertilizers** A mixture of equal parts of bone meal, seaweed meal, and hoof and horn gives a good balance of nutrients. A rate of 30g per plant per week will feed tomatoes in 10-litre pots, whereas half the amount every couple of months is more suitable for a bay tree in a similar pot. Sprinkle the fertilizer mixture on to the surface of the compost or into holes made with a cane.

• **Top-dressing with compost or well-rotted manure** On borders, apply them at the same rate as you would for digging in (see page 17). The richness and fine texture of worm compost makes it most suitable for top-dressing pots and other containers – use about a 1cm layer.

• **Mulching with comfrey leaves** A 5cm layer on borders will slowly rot down and release nutrients.

• **Liquid feeding** You can buy organic liquid feeds or make them yourself. They are useful for giving plants a boost, e.g. when they are growing quickly, cropping heavily, or are recovering from pest attack. However, you should rely on them as little as possible. Proprietary organic liquid feeds are usually based on animal manures, and DIY ones on manure, comfrey, or nettles.

A traditional way of making a liquid feed is to soak manure in water. Quantities are rarely given and are difficult to specify since manures vary so much in composition. For well-rotted manure, try a 10-litre bucketful in 200 litres of water. The resulting liquid should be the colour of weak tea and can be used directly on cropping plants. Instructions for making comfrey and nettle liquids are given on the opposite page.

Pure seaweed liquids contain only very small amounts of the major plant nutrients, which are

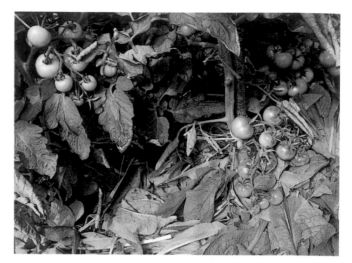

Tomatoes in a border mulched with comfrey leaves. The more finely chopped the leaves are, the quicker they will rot down.

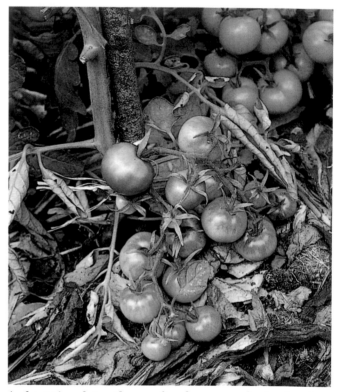

A short time later the comfrey leaves are beginning to rot down.

not sufficient to feed plants in the same way as the other liquid feeds described here. However, they do contain essential trace elements and also natural growth promoters. Therefore, they can help plant growth, particularly root development, and in some cases can help increase the resistance of plants to pests, diseases, and frost. Use them at the recommended dilution either as a soil drench or a foliar spray.

DIY comfrey and nettle feeds

Comfrey liquid

The leaves of the vigorous hybrid plant Russian comfrey, *Symphytum* x *uplandicum*, are rich in nutrients. They contain little fibre and, once cut, decompose rapidly into a thick dark liquid. This is relatively odourless compared to most DIY liquid feeds and stores well. It is an excellent source of potassium and contains smaller amounts of nitrogen and phosphorus. Dilute it ten to twenty times with water before use, depending upon the strength of feed required; e.g. fruiting vegetables in pots benefit from about a 15:1 dilution (15ml water for every 1ml comfrey liquid) fed to them three times weekly when they start to form fruit. For pot plants use a 20:1 dilution once a week when they are growing strongly.

Nettle liquid

The liquid resulting from soaking nettles (*Urtica dioica*) in water is also a valuable plant food. It has a high nitrogen content and contains smaller amounts of potassium, phosphorus, and other minerals and trace elements, although its exact composition will vary with the year, the season, and the place where the nettles are growing. Young nettles picked in spring have the highest nutrient value. The liquid is best made in a sealed barrel (it is very smelly) and drawn off through a tap. Use approximately 1kg nettles per 100 litres of water. Use the liquid directly on fruiting plants such as tomatoes; dilute it with an equal amount of water for pot plants. Nettle liquid can also cause a rise in pH.

barrel with lid

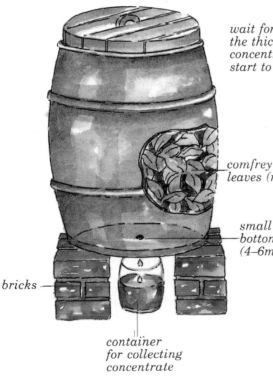

wait for 7–10 days, and the thick dark comfrey concentrate should start to drip out

comfrey leaves (no water)

small drip hole in bottom of barrel (4–6mm in diameter)

bricks

container for collecting concentrate

Caution Decomposing comfrey leaves and comfrey liquid are alkaline and if used regularly at a high concentration they could cause a detrimentally high pH, especially on soils that are already alkaline. Do not use on acid-loving plants such as azaleas.

Plant raising

Using a greenhouse to raise your own plants from seeds and cuttings has many advantages.

• You can grow plants that otherwise you would have to buy, such as bedding plants, tomatoes, and cucumbers. This saves money, gives a much wider choice of varieties, and reduces the danger of bringing in pests and diseases.

• You can give a head start to plants normally sown outside, e.g. spring lettuce, summer cabbage, and annual flowers. As well as getting earlier crops, you reduce the risk of pests and diseases attacking the vulnerable young seedlings. This is an important way for organic gardeners to overcome some pest and disease problems.

• You can have great fun experimenting – growing houseplants from seed, or rooting cuttings from your favourite shrubs.

Although you can do some of this on your kitchen window-sill, a greenhouse gives you much more scope and generally much better quality plants.

Growing from seed

This can be a cheap and easy way of producing plants. Also, since few diseases are carried in seeds, it is unlikely to introduce problems into your garden.

Whether you are growing vegetables, flowers, shrubs, or trees, it is important to find out the conditions that the seeds need to germinate and grow quickly.

Good seed

It would be ideal to use organically grown seed, but very little, if any, is commercially available. It is possible to save seed from your own garden, and for some crops and flowers this is well worth doing. The next best alternative is to buy seed from a company that does not chemically dress the seed after harvesting.

Store seed in a cool, dry place, not in the greenhouse. In warm, damp conditions, seed rapidly starts to lose its vigour, so germination becomes poor and so does the growth of resultant seedlings.

Correct temperature

In general, higher temperatures help seeds germinate more rapidly and get seedlings off to a better start. However, the correct temperature varies for different seeds: the germination of some seeds can be inhibited above, as well as below, certain temperatures.

• Lettuces sown in midsummer: temperatures over 25°C can inhibit the germination of butterhead varieties; crispheads are a little less susceptible.

• Overwintering onions sown in late summer: temperatures over 24°C can inhibit germination.

Avoid problems by sowing these seeds in pots or modules in a shady place outside the greenhouse.

In the chart on the opposite page, the first figure in the temperature column gives the minimum temperature, below which germination becomes very slow and erratic. So, for best results you should aim for temperatures a few degrees above this minimum. The second figure gives the maximum temperature, above which germination is inhibited; this is included only if it is low enough to be easily exceeded by accident.

Seedlings also need the correct temperature for growth. They will not flourish if it is too cold, and will simply grow too quickly and become leggy and weak if it is too hot.

A polythene bag over the pot keeps the seeds moist until they germinate, and still lets in the light if it is necessary for germination.

Moisture and air

As well as the correct temperature, seeds need water and air in order to germinate and grow. Using a good seed compost (see pages 27–9) helps to ensure that it does not become waterlogged, which would deprive the seeds of air, cool them down, and encourage fungal diseases. This is particularly important for seeds that take a long time to germinate, such as parsley.

Light

Many seeds will germinate equally well in light or darkness. However, some will not germinate without light, whilst others, e.g. pansies, do better in the dark (see the chart on page 26). Watch out for specific instructions on the seed packet.

As soon as you can see that the seeds have germinated, keep them in good light but out of direct sunlight.

Special conditions

Some seeds need special treatment before sowing.

Prechilling Some seeds, particularly wild flowers, shrubs, and trees need prechilling to break their dormancy, so they will not germinate until they have experienced a period of cold or a sequence of cold and warmth. This is nature's way of ensuring

Sowing conditions for vegetable seeds

Vegetable	Botanical name	Temp. °C	What to sow in
Broad beans	Vicia faba	5	Pots, trays, or modules.
French beans	Phaseolus vulgaris	12	Pots, trays, or modules.
Runner beans	P. coccineus	12	Pots, trays, or modules.
Beetroot	Beta vulgaris	7	Modules.
Brassicas, most	Brassica spp.	5	Modules, or prick out.
Carrots	Daucus carota	7	Modules, or direct in greenhouse border.
Celery	Apium graveolens	10-19	Modules, or prick out.
Celeriac	A.g. var. rapaceum	10-19	Modules, or prick out.
Cucumbers, greenhouse	Cucumis sativus	20	Pots.
Cucurbits, other	Cucurbita & Cucumis spp.	13	Pots, or modules.
Leaf beet	Beta vulgaris	7	Modules.
Leeks	Allium porrum	7	Modules, or seed-bed in greenhouse.
Lettuce, butterhead	Lactuca sativa	0-25	Modules, or prick out.
Lettuce, crisphead	L. sativa	0-29	Modules, or prick out.
Onions	Allium cepa	7-24	Modules, or prick out.
Parsnips	Pastinaca sativa	7	Modules.
Peas	Pisum sativum	6	Modules, or guttering (see page 27).
Tomatoes	Lycopersicon lycopersicum	13	Modules, or prick out.
Radish	Raphanus sativus	6	Direct in greenhouse border.
Sweetcorn	Zea mays	12	Pots, or modules.

that they come up in spring and not just as the hardship of winter begins. You can trick the seeds into germinating by giving them an artificial winter in the fridge. Put the seeds, mixed in a small amount of damp seed compost, in a polythene bag and place the sealed bag in a refrigerator (not the freezer), for the time recommended for that particular variety – usually about three to six weeks. After this time, remove them from the refrigerator and spread the compost from the bag on to the surface of a filled seed tray, and keep it in the light at the normal temperature for germination. The alternative is to sow the seeds in autumn and leave the pot or tray in a cold frame or plunged up to its rim in the soil in a sheltered spot in the garden, and then bring it into the greenhouse in spring.

Common examples of seeds which need prechilling include angelica (*A. archangelica*), sweet cicely (*Myrrhis odorata*), and primroses (*Primula* spp.).

Soaking The hard coats of some seeds can be softened by leaving the seeds in tepid water for a few hours; this will also help to leach out any substance which inhibits germination. Common examples of seeds for which soaking can speed up germination include morning glory, New Zealand spinach (*Tetragonia expansa*), and beetroot.

Chipping The surface of some hard seeds needs to be chipped with a knife or scratched with emery-paper to allow water to pass through. Common examples of seeds for which chipping or scratching can help germination include bluebell (*Hyacinthoides* spp.), cranesbill (*Geranium* spp.), and hard sweet pea (*Lathyrus* spp.) seeds.

Sowing conditions for half-hardy annual seeds

Half-hardy annual	Botanical name	Temp. °C	Light or dark	Special conditions
Ageratum, floss flower	A. houstonianum	18-25	Light	
Alyssum	Lobularia maritima	15-20		
Antirrhinum, snapdragon	A. majus	15-25	Light	
Begonia	B. semperflorens	18-25	Light	
China aster	Callistephus chinensis	15-20		
Dahlia, bedding	Dahlia	15-20		
Geranium	Pelargonium spp.	15-20		
Heliotrope, cherry-pie	Heliotropium x hybridum	20-5		Give seedlings extra warmth.
Impatiens, busy Lizzie	I. balsamina	20-5	Light	
Lavatera, mallow	L. trimestris	20-5		
Lobelia	L. erinus	15-25	Light	Prick out seedlings in clumps.
Marigold, French	Tagetes patula	18-25		
Nemesia	N. strumosa	18	Dark	Higher temperatures detrimental.
Nicotiana, tobacco plant	N. alata syn. N. affinis, N. x sanderae	18-25	Light	
Pansy	Viola x wittrockiana	15-18	Dark	Higher temperatures detrimental.
Petunia	P. x hybrida	18-25	Light	
Salvia	S. splendens	18-25	Light	
Verbena	V. x hybrida	20-5	Dark	

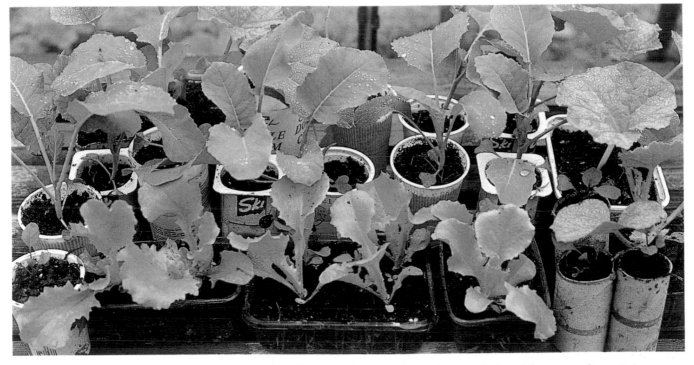

Seedlings and young plants in recycled and home-made containers. Try making your own pots from rolled-up newspaper.

Pots, trays, and modules

Sowing seeds into individual pots is convenient if only a few plants are required, but takes up valuable space on a heated bench. For large numbers – of bedding plants, for example – sow the seeds into a single pot then prick out the seedlings into trays as soon as they are large enough to handle.

The alternative is to sow directly into modules (trays divided into individual cells) or into blocks of compost compressed into shape with a special blocking tool. This saves time on pricking out and avoids the damage and shock that can occur to seedlings

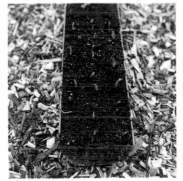

Sowing peas in 1m lengths of guttering in the greenhouse gives them an early start and keeps them out of the way of mice. When the seedlings are 2–4cm high and the roots have filled the gutter, you can slide the contents out into a gutter-shaped drill.

Seedlings growing in modules.

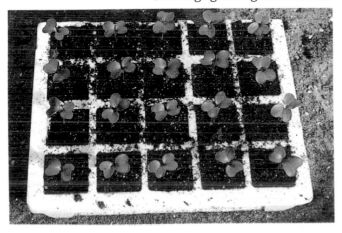

when they are transplanted. It is the best way to sow seeds that are normally sown *in situ* – hardy annual flowers and root vegetables such as beetroot, for example.

Sowing composts

Germinating seeds and young seedlings are delicate and vulnerable, so getting the sowing mixture right can be critical. It needs to be:

• Free-draining, to minimize risk of fungal disease.

• Free from pests and disease organisms.

• Free from weed seeds.

'Seed' composts, used when seedlings are going to be pricked out, need not contain many plant foods

as most of the seedlings' requirements are contained within the seed itself. However, the compost into which they are pricked out, or which is used to fill modules for direct sowing, must contain sufficient food to sustain the young plants for several weeks – ideally until they are planted outside or potted up (using one of the mixtures described on pages 19–20).

Because the sowing mixture is so critical, and only used in small quantities, buying a proprietary brand may be preferable to making your own. The organic 'multi-purpose' composts on the market should be suitable for most seeds, although you may need a 'seed' compost for a few seeds that will only germinate when the nutrient level is very low. If you want your own mixture, use the recipes (in the box on the opposite page) as a guide – they should be successful for at least larger seeds such as beans and cucurbits, and for vigorous ones such as brassicas. The special 'blocking' composts on the

Sowing and pricking out

1. Fill a tray or pot loosely with moist sowing compost so that it is level with the top. Firm it down gently, either with a piece of wood made to size or with the bottom of another pot.

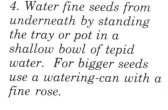

4. Water fine seeds from underneath by standing the tray or pot in a shallow bowl of tepid water. For bigger seeds use a watering-can with a fine rose.

2. Sow the seed as evenly as possible, using your fingers, the tip of a knife, or a plant label. It helps to mix fine seed with about twice its volume of silver sand. Do not sow too thickly – this encourages fungal diseases.

5. Cover the tray or pot with a sheet of clean glass, cling film, or a polythene bag to keep in the moisture until they germinate. For seeds that need darkness for germination, put on an additional thick wad of newspaper, or use black plastic.

3. Cover all but fine seeds with a loose layer of sieved sowing compost to a depth of about twice the diameter of the seed. Leave fine seeds on the surface.

6. Prick out the seedlings as soon as they are large enough to handle. Ease them out with a piece of wood or a plant label, holding them only by their seed leaves, never by the stems.

7. Space them out in a tray of moist multi-purpose compost, giving each one enough space to become a sturdy plant. When the tray is full, water with a fine spray from a watering-can or hand sprayer. Alternatively, sow seeds in a tray of individual modules, so no transplanting is necessary.

market are designed to hold together well when compressed. They usually rely upon a mixture of different types of peat for their stickiness and are not easy to make yourself.

Home-made sowing composts

You can use these mixtures like multi-purpose composts, in modules and small pots. Check the pH of your mixture. It should be around 6.0. If it is too high, then add dolomite lime or calcified seaweed.

• 1 part sterilized loam, 1 part sieved leaf mould or coir, 1 part sharp sand.

• 2 parts sieved comfrey leaf mould, 3 parts sieved leaf mould.

• For a very low nutrient seed compost, try sieved leaf mould on its own.

Taking cuttings

The other common way of propagating plants is from cuttings. These are normally pieces of the stem, although some plants can be propagated from pieces of leaf or root. Plants produced in this way have identical characteristics to the parent plant, and you can use cuttings to propagate many named varieties and hybrids that do not come true from seed. A greenhouse is a great advantage for rooting most cuttings.

The aim with any type of cutting is to induce it to produce new roots as quickly as possible. If you choose the material carefully and provide the right conditions, rooting powders, which are designed to aid rooting, should not be necessary. They contain synthesized plant hormones and fungicides, not acceptable to organic gardeners.

Stem cuttings

Softwood cuttings are taken from new soft shoots of herbaceous plants that will not turn woody; from spring growth of some shrubs; and from ornamental greenhouse plants such as fuchsias, geraniums, and chrysanthemums.

Semi-ripe cuttings are taken later in the season, from shoots that have started to harden and turn woody and brown at the base.

Where to cut

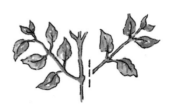

Basal cutting *Cut with a sharp knife through the swelling at the base of the shoot where it joins the main stem.*

Nodal cutting *Cut just below a leaf joint.*

Heel cutting *Pull off the shoot with a tail of old wood attached.*

Internodal cutting *Cut about half-way between two leaf joints.*

Hardwood cuttings are from wood that has become fully mature at the end of the season.

The most successful method depends upon the particular plant. The chart on page 30 gives a guide to some of the common examples of cuttings from shrubs that can be propagated in an unheated greenhouse. It is often worth experimenting for yourself with these and other plants.

Guide to taking stem cuttings from shrubs

Shrub	Botanical name	Type of cutting	Cm / Length	When
Barberry, deciduous evergreen	*Berberis*	Basal, heel, or nodal semi-ripe Hardwood, as above	10-15	Early to mid-autumn Early to late autumn
Box	*Buxus*	Hardwood	7-15	Early to late autumn
Buddleia	*Buddleia*	Nodal, softwood or semi-ripe Hardwood	10 25	Late spring to midsummer Late autumn to early winter
Ceanothus	*Ceanothus*	Basal or heel semi-ripe	10-13	Early to late summer
Japanese quince, japonica	*Chaenomeles*	Basal, softwood or semi-ripe	8	Early summer
Dogwood	*Cornus*	Hardwood	20	Late autumn
Cotoneaster	*Cotoneaster*	Basal hardwood	20	Mid-autumn
Escallonia	*Escallonia*	Basal, heel, or nodal semi-ripe	10-15	Midsummer to mid-autumn
Veronica	*Hebe*	Softwood or semi-ripe	8-15	Late spring to early summer or early to mid-autumn
Ivy	*Hedera*	Nodal semi-ripe	8-10	Early to midsummer
Hyssop	*Hyssopus*	Basal softwood	5-8	Mid to late spring
Holly	*Ilex*	Nodal semi-ripe	10	Early to late autumn
Lavender	*Lavandula*	Softwood or heel semi-ripe	5-8	Mid-spring to early autumn
Honeysuckle	*Lonicera*	Trim stems 3cm either side of a leaf joint		Early to midsummer
Mock orange	*Philadelphus*	Nodal semi-ripe Hardwood with heel	10 20	Early to midsummer Late autumn to early winter
Firethorn	*Pyracantha*	Heel semi-ripe	10-15	Early autumn
Flowering currant	*Ribes*	Hardwood	20-5	Mid-autumn
Rosemary	*Rosmarinus*	Softwood Heel or basal semi-ripe	8-10 8-10	Late spring to early summer Midsummer to early autumn
Sage	*Salvia officinalis*	Softwood Heel semi-ripe	10 10	Late spring to early summer Midsummer to early autumn
Thyme	*Thymus*	Nodal or heel semi-ripe	8-10	Late spring to early autumn
Viburnum	*V. bodnantense* *V. davidii* *V. fragrans* *V. tinus*	Nodal hardwood Softwood or semi-ripe Nodal hardwood Softwood or semi-ripe	13 8-13 13 8-13	Mid-autumn Early to midsummer or early autumn Mid-autumn Early to midsummer or early autumn
Weigela	*Weigela*	Basal softwood or semi-ripe Hardwood	13 23	Early summer Mid to late autumn

Materials for cuttings

The shoots that you use for cuttings should be:

• From healthy plants – diseases, including viruses, will almost certainly be transmitted to new plants.

• From young vigorous plants, or from vigorous growth on old plants (often this occurs where they have been pruned recently).

• Stocky, not drawn and spindly, and there should be only short lengths of stalk between the leaves or leaf buds.

• Non-flowering where possible, otherwise cut off any flowers or flower buds.

Compost for cuttings

The compost mixture used to root cuttings needs few nutrients; in fact, rooting can sometimes be inhibited by too high a nutrient level. However, it must be well drained so as not to encourage fungal diseases.

Proprietary seed composts are often suitable for cuttings. If you are making your own, then try a mixture of equal parts of leaf mould and grit or one of the sowing composts on page 28 mixed with an equal amount of grit. For hardwood cuttings, you could fork leaf mould and grit into a small patch in the greenhouse border, but remember that the cuttings may have to stay there for six months or more.

Conditions for rooting

Warmth at the base of the stem and humidity are the essential conditions for rooting, particularly for softwood cuttings, which are delicate and lose water very quickly. A propagator with soil-warming cables is ideal for these. However, temperatures that are too high, or too much moisture, can inhibit rooting and encourage rotting. (See chart above for further details.)

Preparing and rooting cuttings

Remove leaves from the lower third to half of each cutting. The number of cuttings that you need will depend upon how easily they root; normally six cuttings will give you at least two plants, but take more of those that are hard to root.

Insert cuttings into holes in the compost made with a dibber or pencil. Space them out so that they

Conditions for rooting

Cutting	Temperature of compost	Humidity	Shade
Softwood	Ideally around 18°C	Very humid. Keep compost moist. Use a fine hand sprayer to increase humidity between waterings if necessary. Cover pots on an open bench with a cut-off plastic bottle or polythene bag.	Shade the pots or propagator until the cuttings have rooted.
Semi-ripe	The ideal temperature is 15-18°C. Many will root without artificial heat in summer. A propagator will often speed up rooting and improve the success rate. Make sure conditions are not too warm in summer.	Fairly humid. A covered propagator is ideal. Cover cuttings on an open bench as for softwood cuttings.	Less delicate than softwood cuttings but still need some shade, especially those taken in midsummer.
Hardwood	Most root without artificial heat, but using a propagator or even just bringing them into the greenhouse will make them root more easily.	Less humidity needed, but evergreens may be better if covered.	Shading not usually necessary, as cuttings are taken in autumn and winter when light levels are low.

do not touch – overcrowding increases the risk of fungal disease. A 15cm pot should hold about six cuttings.

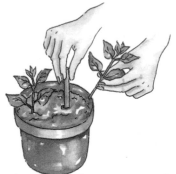

Softwood, semi-ripe, and evergreen hardwood cuttings are best if covered. If you do not have a propagator, then cover each with a polythene bag supported on wire hoops, or with a large plastic bottle that has had the bottom cut off.

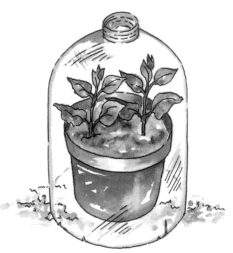

Check the cuttings regularly, and remove yellowing or fallen leaves. You will know that the cuttings have rooted when the tips start to grow rapidly, or when you can see white roots at the bottom of the pot. Take off the plastic cover, and a few days later, when they have had a chance to acclimatize, pot them up into a multi-purpose compost.

Hardening off

Before plants raised from seed or cuttings are planted in the garden, you must get them used to the harsher conditions outside. First, put them out during the day in fine weather, giving them some shade and shelter if necessary. Unless you have purpose-built cold frames you will need to bring them back in at night for a few days. Gradually reduce the amount of protection you give them over a period of about a week until they are fully acclimatized.

Echeveria leaves root easily in moist compost to form new plantlets at their bases.

Leaf cuttings

Whole leaves with short stalks are inserted into moist compost so that the base of the leaf just touches the soil. Some succulents, e.g. *Echeveria*, and houseplants such as African violets (*Saintpaulia*), gloxinias (*Sinningia speciosa*), and Rex and rhizomatous begonias may be increased in this way. Scored or cut leaves with the stalks removed can be used to increase plants such as *Begonia rex* and Cape primrose (*Streptocarpus*). The leaf veins are scored, or the leaf cut into small sections, and the cut veins kept in contact with moist compost. The containers of cuttings can be covered with clear, inflated plastic bags, or the cut-off bases from plastic drinks bottles, until plantlets are produced.

Greenhouse plants

This section gives information on growing and caring for a variety of specific plants, including half-hardy summer vegetables, winter vegetables and salads, herbs, fruits, and flowers. Of course, the list is by no means complete, but it does cover a wide range of useful and decorative plants.

Half-hardy summer vegetables

Half-hardy vegetables that are slow to mature, such as peppers, aubergines, cucumbers, and tomatoes, need space in the greenhouse all summer to give a worthwhile crop. Others, such as courgettes and French beans, start to crop quickly and can be cleared when outdoor crops are ready.

In both cases, the plants must be started off when the temperature outside is still cold, so you will need to provide some heat to raise them yourself. The alternative is to buy plants in at planting time.

Tomatoes *Lycopersicon lycopersicum*

Varieties
There is a wide choice: from small cherry to large beefsteak fruit, with red, yellow, or striped skins. You do not need a special greenhouse variety – all generally grow better in a greenhouse than outside, and those described as outdoor tomatoes may be the best choice for greenhouse-growing in cold areas. Some modern varieties are bred for disease resistance and may be worth considering if you have trouble with root rots or viral diseases (see page 58). Upright, cordon varieties give the best value for space in a greenhouse border, but bush varieties are useful, for example, in hanging baskets and in pots on the bench.

Sowing
Sow seeds in one pot for pricking out, or in small (3cm) individual pots, approximately eight weeks before planting. Aim for a temperature of about 18°C for germinating the seeds and bringing on young plants for the first few weeks.

Planting
Plant out as soon as conditions are at least frost-free and soil temperatures are above 10°C – usually sometime in late spring in an unheated greenhouse. Tomatoes do best in a well-manured or composted greenhouse border, planted 45cm apart. However, you can get good yields by growing them

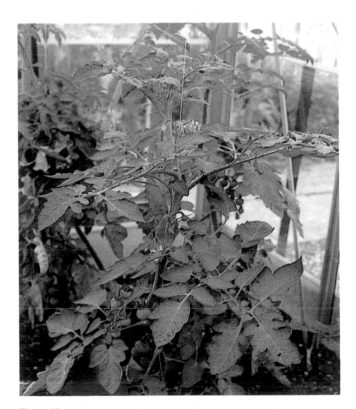

Tie tall tomato varieties to canes, or twine them around strings as shown.

in 25–30cm pots, or by ring culture (see page 20), provided that enough attention is given to feeding and watering.

Growing
Tall varieties need supporting with canes or string right from the start, and also need all their side shoots pinching out. Bush varieties need no such training. Tomatoes need good light and well-ventilated airy conditions. Do not let the soil dry out.

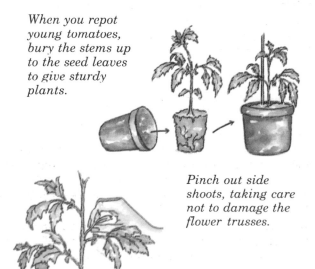

When you repot young tomatoes, bury the stems up to the seed leaves to give sturdy plants.

Pinch out side shoots, taking care not to damage the flower trusses.

33

Harvesting
Harvest from midsummer to mid-autumn. Pick the ripe fruit regularly to encourage more to be produced.

Pests, diseases, and disorders (see pages 48–62)
The main pests of tomatoes are whitefly, aphids, tomato moth, and root eelworm; they are also subject to various foot and stem rots and viruses. The most common disorders are magnesium deficiency, leaf curl, and blossom end rot. Good husbandry should avoid most of these problems.

Cucumbers *Cucumis sativus*

Varieties
There is a distinct difference between greenhouse and outdoor varieties. Greenhouse varieties produce the long smooth cucumbers you see in the shops. The male flowers of traditional greenhouse varieties must be removed constantly to avoid bitter fruit, but modern all-female varieties avoid this problem. Outdoor ridge cucumbers are shorter and pricklier, although modern varieties are less extreme. They grow well in a greenhouse, and are the best choice for unheated greenhouses in cold areas. Look out for varieties with resistance to powdery mildew.

Sowing
Sow seeds in individual 9cm pots four to five weeks before planting, at about 21°C for all-female greenhouse varieties, and about 18°C for others. Sow the flat seeds on their edges to avoid water collecting on them and causing rotting. Keep the young plants warm, ideally at around 20°C.

Planting
The young plants are very sensitive to cold. Greenhouse varieties need temperatures above 15°C,

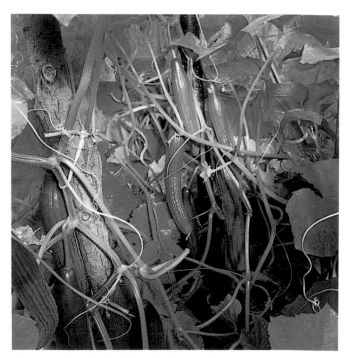

A cucumber trained up home-made supports.

which usually means planting in early summer in an unheated greenhouse. You could screen off part of the greenhouse to give the plants the extra warmth and humidity that they need. Outdoor varieties are slightly hardier. Like tomatoes, cucumbers do best in a well-composted or manured border, but they can be grown in 30–7cm pots. They were traditionally grown in hot beds (see page 14). Make sure that the borders or beds are well drained. Take care not to bury the stem when planting, and avoid watering right at its base.

Growing
All-female varieties produce cucumbers at the leaf joints on the main stem. Thus, you can remove all the side shoots on these varieties and train them like tomatoes. Other varieties are best trained on a network of strings or wires, or on large mesh netting. Here, the cucumbers are produced on side shoots, which should be pinched off one leaf beyond the developing fruit. Water the plants regularly once they are established. A thick mulch of hay or

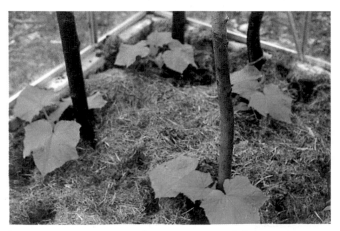

Young cucumbers in a heavy grass mulch.

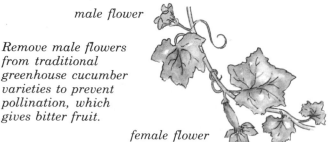

male flower

Remove male flowers from traditional greenhouse cucumber varieties to prevent pollination, which gives bitter fruit.

female flower

straw will help to keep the beds moist and also to create a humid atmosphere.

Harvesting
Harvest from late summer to mid-autumn. Pick regularly to encourage further fruiting.

Pests, diseases, and disorders (see pages 48–62)
The main cucumber pests are red spider mite, aphids, and whitefly. Stem or foot rots can also be a problem, particularly with young plants. Older plants are frequently affected by powdery mildew, particularly at the end of the season if the weather is hot.

Sweet peppers *Capiscum annuum*

Varieties
Sweet pepper varieties include chilli peppers, and vary in colour and shape of the fruit. Most are green at first, but can become red, yellow, orange or purple-black when mature. Hot cayenne peppers are a different species (*C. frutescens*). Compact varieties of both types are good for growing in pots.

Sowing and planting
Sow and plant as you would tomatoes, but keep the plants warmer if possible. They grow more slowly, especially if the temperature is low, and can take ten weeks or more to be ready for planting out. Keep them with tomatoes in the crop rotation. They will do well in large 25cm pots on the greenhouse bench, which makes good use of space.

Growing
Pinch out the growing point when the plants are about 30cm high to encourage bushy growth. Tie them to short canes when the fruit forms, as they may become top heavy. They need good light and well-ventilated conditions.

Harvesting
Harvest from late summer to early autumn. For the best yield, pick early fruit when green to encourage more to develop. Leave later fruit to turn colour.

Pests, diseases, and disorders (see pages 48–62)
The main problems are aphids, whitefly, and red spider mite.

Aubergines *Solanum melongena*

Varieties
Both purple and white varieties are available. Early-to-mature purple varieties are the best for an unheated greenhouse.

Sowing, planting, and growing
As for peppers, although aubergines are more difficult to grow successfully.

Sweet pepper growing in a pot in the greenhouse.

Aubergines grow happily in pots in the greenhouse. The variety on the right is called 'Easter Egg'.

Harvesting
Late summer to early autumn.

Pests/diseases/disorders (see pages 48–62)
As for peppers, but they are particularly prone to red spider mite.

Courgettes and squashes *Cucurbita spp.*

Varieties
F1 hybrid courgette varieties usually begin cropping earlier and produce more fruit. Look out for varieties resistant to cucumber mosaic virus. Other summer squashes could also be grown, but look out for bush varieties – many other varieties will be too rampant.

Sowing
Sow in individual 8–9cm pots at a temperature of 18–21°C, approximately five weeks before planting out.

Planting
Plant in the greenhouse border as soon as conditions are frost-free – usually in late spring. The border should be well manured or composted. Allow 1sq m per plant. Keep with cucumbers in the crop rotation.

A summer squash 'vegetable spaghetti' growing in the greenhouse border.

Harvesting
Harvest from early summer to mid-autumn, or until cleared to make way for autumn crops. Harvest regularly, or you will quickly end up with marrows!

Pests, diseases, and disorders (see pages 48–62)
The plants are generally vigorous enough to overcome most problems, although cucumber mosaic virus can ruin the crop. Powdery mildew may affect established plants in hot weather.

French beans *Phaseolus vulgaris*

Varieties
Dwarf varieties crop earlier and over a shorter period, although climbing varieties give higher yields for a given space.

Sowing
Sow in deep trays or individual pots at a temperature of about 15°C, approximately four weeks before planting.

Planting
Plant out in the greenhouse border as soon as conditions are sufficiently frost-free – usually in late spring in an unheated house – up until mid-summer. Space climbing varieties 30cm apart, and dwarf varieties 20cm each way. The border should contain plenty of organic matter, but need not be very rich.

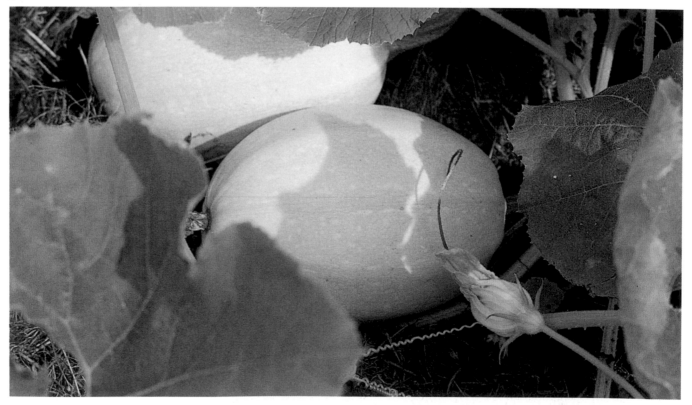

Growing
Grow tall varieties up canes or strings. Ensure that plants are kept moist and that ventilation and light are good.

Harvesting
Dwarf varieties produce the earliest crops from early to midsummer; or from early to mid-autumn for early summer-sown crops. Climbing varieties take longer to crop but have a longer harvesting time. Pick regularly.

Pests, diseases,and disorders (see pages 48–62)
Beans, when grown in a greenhouse, are particularly prone to red spider mite.

Winter vegetables and salads

Leafy winter salads give very good value for the space available in an unheated greenhouse, and this need not mean just lettuce: many chicories, endives, and oriental brassicas, for example, are hardier and less trouble to grow. They will provide you with leaves of different reds and greens, and mild and hot flavours, that you rarely find in the shops.

Sowing these crops in late summer will ensure that plants are established and harvesting can begin before winter sets in. Although at this time the greenhouse borders are often taken up with tomatoes and other summer crops, the problem can be overcome.

• Set aside a part of the border to be cleared in late summer. You can use this space for an early crop of courgettes or beans (see page 36).

• Sow in pots or modules for transplanting when summer crops are cleared.

• Space late plantings closely and cut them earlier, before they are mature. Many will resprout.

• Sow seedling crops (see box).

Although many vegetables will give an early harvest if sown under cover in autumn or early spring, most take up too much space to give worthwhile yields in a garden greenhouse. Radishes, spring onions, and carrots are useful exceptions, whilst mangetout peas, florence fennel, and spinach may be worth a try if you have room. Usually, no special preparation is needed for borders that have already been manured or composted for summer crops, but it is important to maintain the crop rotation.

Seedling crops
A quick way to produce a salad crop is to broadcast a patch of seed relatively thickly, and to cut the leaves when they are very young, generally 5–7.5cm high. Crops that can be grown like this include cress, salad rape, spinach, lettuce, and salad rocket. You can also buy mixtures of seeds, or mix your own. Only small patches are needed, but the seed-bed must be fine and weed-free. The crop can be ready for cutting in as little as four weeks, even in late autumn or early spring. The seedlings will usually resprout, and can be cut several times.

Cut-and-come-again crops
Many plants will resprout even if they are cut when more mature: for example, many chicories, endives, and loose-leaf or cutting lettuces. Often, plants cut in autumn will overwinter as not much more than a stump, but will produce a fresh crop of leaves in the spring.

Cut-and-come-again lettuces.

'Red Verona' and 'Castel Blanco' chicories.

Sowing, planting, and harvesting times for vegetables and salad crops

Crop	Botanical name	Sow	Plant	Harvest
Carrot	*Daucus carota*	Late winter		Late spring to early summer.
Chinese cabbage	*Brassica rapa var. pekinensis*	Early autumn in modules	Early autumn 30cm apart	Late autumn to midwinter. Heads could be left to resprout if the space is not required. Alternatively, plant closer for a cut-and-come-again crop. Keep with brassicas in crop rotation.
Chicory	*Cichorium intybus*	Late summer in situ or in modules	Early autumn 15cm apart	Late autumn to late spring. Red, sugar loaf, or grummolo varieties. Cut-and-come-again crops. Keep with lettuce in crop rotation.
Corn salad, lamb's lettuce	*Valerianella locusta*	Late summer in situ or in modules	Early autumn 10cm apart	Late autumn to mid-spring. Cut-and-come-again crop. Mildew can be a problem.
Endive	*Cichorium endiva*	Late summer in situ or in modules	Early autumn 20cm apart	Late autumn to mid-spring. Cut-and-come-again crop. In general, the broad-leaved endive varieties are hardier than the curly ones. They require little or no blanching. Keep with lettuce in rotation.
Florence fennel	*Foeniculum vulgare var. dulce*	Late summer in situ or in modules	Early autumn 30 cm apart	Early to mid-spring. Thin to final spacing in spring if direct sown. Keep with carrots in crop rotation.
Lettuce, heading	*Lactuca sativa*	Early autumn in modules / Late winter	Early autumn to mid-autumn 30cm apart / Late spring	Early to midwinter. Use variety for winter greenhouse growing. Late spring to early summer. Use variety for early cropping under cover.
Lettuce, cutting	*L. sativa*	Early summer in modules outside, in case temperature is too high for germination / Early autumn in modules	Late summer 15-20cm apart / Early autumn 15cm apart	Early to mid-autumn. / Late autumn to early spring. Use winter-hardy variety.
Oriental greens and oriental mustards	*Brassica rapa & B. juncea*	Late summer in situ or in modules	Early autumn Spacing depends upon variety	Late autumn to early spring. Choose hardy varieties, e.g. mizuna and green-in-snow. Cut-and-come-again crops. Keep with brassicas in crop rotation.
Landcress	*Barbarea verna*	Late summer in situ or in modules	Early autumn 15cm apart	Late autumn to mid-spring. Cut-and-come-again crops.
Onions, spring	*Allium cepa*	Late summer in situ or multisown in modules	Early autumn	Late winter to early spring.
Peas, mangetout	*Pisum sativum*	Mid-autumn		Late spring to early summer.
Radish	*Raphanus sativus*	Early autumn / Late winter		Mid-autumn. Early spring. Choose a variety recommended for winter growing under glass.
Spinach	*Spinacia oleracea*	Late summer		Midwinter to mid-spring. Choose a winter-hardy variety.

Herbs

Herbs easily earn their place in any greenhouse – they produce so much flavour in a small space!

Summer harvest

Basil (*Ocimum basilicum*) and sweet marjoram (*Origanum vulgare*) flourish inside in the summer. Although they are perennial in hot climates, it is easiest to grow them fresh from seed each year.

Sow seeds in early spring at a temperature of about 20°C, and keep young plants warm. Repot as necessary. Plant in the greenhouse border, or keep in pots, but use 20cm pots for basil as it needs plenty of nutrients.

To encourage new bushy growth, plants for culinary use must be picked continually and not allowed to flower. You should then be able to use them until late autumn. Aphids are the main problem.

Winter protection

In winter, the greenhouse is useful for protecting tender perennial herbs: for example, bay (*Laurus nobilis*), lemon verbena (*Aloysia triphylla*), and some species of lavender such as *Lavandula dentata* and *L. stoechas*. These all grow well in pots and can be put outside in the herb garden in summer.

Many varieties of rosemary (*Rosmarinus* spp.) also benefit from winter shelter in cold areas. They will flower in the greenhouse from late winter onwards, giving blooms in all shades of blue from deep marine to almost white.

Top-dress established plants with worm compost, but be prepared to renew all of them except the slow-growing bay every three to four years. Left longer, they become woody and straggly or outgrow their pots. Scale insects are the main pest on bay trees, otherwise there are few problems.

Winter harvest

In the garden, clumps of herbaceous herbs such as chives (*Allium schoenoprasum*) and tarragon (*Artemisia dracunculus*) often need dividing in autumn. Put surplus pieces in pots and bring them into the greenhouse to produce fresh sprigs in early spring. Discard them when outdoor plants are ready for harvesting.

You can also harvest parsley (*Petroselinum crispum*) and chervil (*Anthriscus cerefolium*) most of the winter. Sow parsley in late summer in pots or in modules for planting later in the greenhouse border. Sow chervil at any time in autumn or spring as a seedling crop (see page 37).

Herbs from hot countries, like the varieties of basil shown here, flourish in the greenhouse in summer.

Less hardy herbs, like rosemary or bay, can be brought into the greenhouse for winter protection.

Parsley, grown in the border, will be useful for picking in the winter.

Fruit

Victorian kitchen gardens often had a separate greenhouse just for a grape-vine, and a peach house for fan-trained peaches or nectarines. However, you can grow fruit productively with other crops in a small greenhouse. Strawberries in pots or hanging baskets only occupy the space for a few months at the beginning of the year and can give you a very early crop. Melons are annuals, grown like cucumbers, and a grape-vine can be accommodated along with other plants provided that you prune it rigorously to keep it in check. You could even grow a fig tree in a pot and move it outside for the summer.

Strawberries *Fragaria x ananassa*

Varieties
Any variety will do (you can take runners from your garden plants), but an early one is best.

Planting
Pot up plants in late summer, and pot on when necessary into 15cm pots of nutrient-rich potting compost. Keep the pots outside in a cold place for the first part of the winter – this chilling induces good flowering and fruiting. In midwinter, bring them into the greenhouse and gradually begin watering. Start to feed them when the flower buds appear, and keep the greenhouse well ventilated once these begin to open.

Harvesting
Harvest from late spring to early summer. You cannot force the same plants twice, so when fruiting has finished discard them or plant them in the garden.

Pests, diseases, and disorders (see pages 48–62)
Because the plants are inside for so short a time early in the year few problems occur, but watch out for aphids.

Alpine strawberries (Fragaria vesca) *provide small sweetly scented fruits, and can be grown from seed.*

Sweet melons *Cucumis melo*

Varieties
Choose a cantaloup variety such as 'Sweetheart' F1 or 'Ogen', as other types usually need some heat.

Sowing and planting
As with greenhouse cucumbers (see page 34), take particular care to protect the stem from rotting. You can let the plants ramble over the ground or bench, or scramble up netting, but they will take up less space if you tie them up canes or string like cucumbers. Pinch out the side shoots one leaf beyond a developing fruit, and do not allow each plant to produce more than three or four fruits. Unlike cucumbers, melons must be pollinated in order to fruit. Insects should do this for you, but if fruit does not develop, then try doing it by hand.

To pollinate a melon by hand, remove the petals from a male flower and gently dab it into the centre of a female flower.

Harvesting
Harvest from late summer to early autumn.

Pests, diseases, and disorders (see pages 48–62)
Powdery mildew and red spider mite are the main problems.

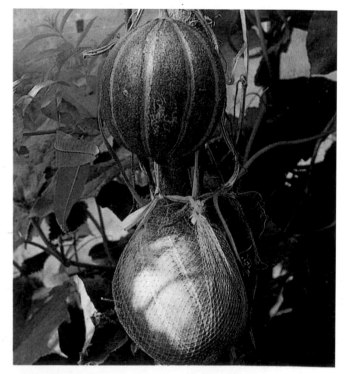

Cantaloup melons are supported here in mesh nets.

Grapes *Vitis vinifera*

Varieties

Choose a variety suitable for cropping in a cold greenhouse – 'Black Hamburgh' is one that is widely available. Outdoor varieties usually produce grapes more suitable for wine making, whilst some greenhouse varieties such as muscats need heat in most areas.

Planting

Good drainage is essential, so provide a soakaway if there is any danger of waterlogging. Dig a large planting hole, and make a mixture of good soil and compost (roughly 3:1), or good soil, manure, and leaf mould (roughly 4:1:1), for planting into – add a handful each of bone meal and seaweed meal. Ideally, plant the grape-vine between late autumn and late winter, cutting the plant back to 15cm.

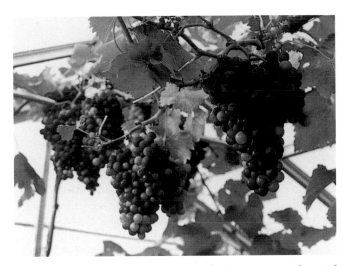

'Black Hamburgh' grapes ripening in an unheated greenhouse.

Pruning grape-vines

1. First summer *Allow one main stem to grow. Shorten the side growths to five leaves, and any secondary growths from these to one leaf. Pinch off any flowers that form. Tie in growths loosely to strong horizontal wires spaced 23cm apart.*

3. Following summer *Allow the main stem to extend. Tie in one side shoot from each bud, rubbing off any extra. Let one or two grow until flower trusses form and stop them two or three leaves beyond. Shorten the others as before, and shorten any secondary growths.*

2. Following winter *Cut back the main stem by about half, and side growths to about 2.5cm, leaving one or two good buds.*

4. Following winter *Cut back new growth on the main stem by half, and the side growths as before.*

5. Subsequent years *In summer, tie in single side growths as before. Allow them to grow until flowers form, and pinch them out two or three leaves beyond the bunches. Pinch out secondary growths to one leaf. Stop the main stem when it has filled its allotted space. In winter, cut back side growths as before.*

Growing

In a small greenhouse, train just a single permanent stem or rod, which each year will produce the side shoots upon which grapes form. This will give a worthwhile crop without taking over completely, although you must be prepared to spend time pruning, tying in, and thinning (see page 41). Keep the vine well watered from the time that growth starts in spring right through the summer, and mulch with compost or well-rotted manure. To get the best grapes and reduce the risk of fungal disease, thin out the grapes when they are the size of small peas, removing the inner ones and tiny ones from each bunch with pointed scissors. Reduce watering when they start to ripen, and ventilate the greenhouse well.

Harvesting

Harvest from early to mid-autumn.

Pests, diseases, and disorders (see pages 48–62)

Mealybug and red spider mite are common pests; powdery mildew and botrytis the most troublesome diseases.

Annual flowers

Growing annual flowers from seed is a cheap and easy way of making a greenhouse attractive – not only to humans, but also to pollen- and nectar-seeking insects. When the plants outgrow their welcome you can discard them and try something new the following year.

A gazania in a pot in the greenhouse.

Half-hardy annuals

Many half-hardy annuals often used as garden bedding plants flourish in the warm summer conditions in the greenhouse. Plants like gazanias and Swan River daisies (*Brachycome ibiderifolia*) often produce much better blooms than they do outside, battered by wind and rain.

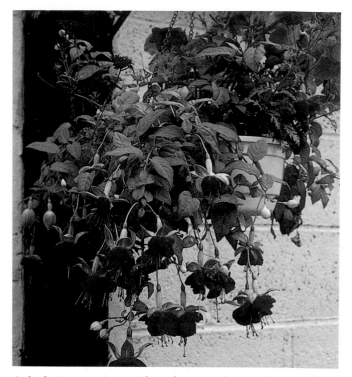

A fuchsia, growing with verbena and petunias, trails from a hanging basket in a lean-to greenhouse.

Half-hardy morning glory climbs up the framework.

Compact or dwarf varieties of, for example, busy Lizzie (*Impatiens*), *Salvia, Ageratum,* and French marigolds (*Tagetes*) are the most suitable for growing in pots. Single varieties are the best for bees and other insects.

Trailing plants such as lobelia, verbena, and petunias do well in hanging baskets or pots attached to the greenhouse wall.

Half-hardy climbers such as morning glory (*Ipomoea*) and black-eyed Susan (*Thunbergia alata*) can be left to scramble up the framework, or can be trained up strings or netting.

Sowing

For early blooms, sow half-hardy annuals in late winter to early spring in heat (see table on page 26). Prick out and grow on in pots or trays; some heat will still be needed at first. Plant in the greenhouse border, hanging baskets, or 15cm pots in mid- to late spring. For fresh plants later in the summer, make another sowing in mid-spring. No heat should be necessary to raise these, and they should flower well into the autumn.

Hardy annuals

Hardy annual flowers are not suitable for growing in the greenhouse in summer; they become leggy and go to seed quickly. However, those hardy enough for autumn sowings will grow well under cover in winter and produce a very early show of flowers. Many of them are amongst the best attractant plants for insects.

Varieties

Choose compact species for growing in pots or as a border edging: poached egg plants (*Limnanthes*

Taller annuals like Californian poppies (Eschscholzia californica) *also give earlier blooms in the greenhouse.*

douglasii), baby blue eyes (*Nemophila menziesii*), and dwarf pot marigolds (*Calendula officinalis*) are a good choice.

Taller plants such as clarkia (*C. amoena*), cornflowers (*Centaura cyanus*) and Californian poppies (*Eschscholzia californica*) need more space in the greenhouse border.

Compact varieties of biennials such as wallflowers (*Cheiranthus*) and forget-me-nots (*Myosotis*) also do well in pots.

Sowing

Sow biennials in midsummer, either in a pot for pricking out or in modules. Plant out into the border in early to mid-autumn. Sow annuals in late summer to early autumn, either in modules or directly into the greenhouse border.

Poached egg plants (Limnanthes douglasii) *produce early flowers in the border.*

Dwarf wallflowers (Cheiranthus) *bloom in early spring.*

Bulbs, corms, and tubers

Winter and spring flowering

Hardy spring bulbs planted in pots will flower a few weeks earlier in the greenhouse than outside, and they will give better blooms unspoilt by wind and rain.

Dwarf varieties and low-growing species are the most successful: scilla, crocuses, dwarf narcissi, tulips, and irises, for example. Taller narcissi will usually need supporting with wire frames or canes and string, which can spoil their appearance although they are still useful for cutting. Tall tulips tend to become very soft and floppy.

Bulbs described as 'prepared' have been subject to artificial temperature changes to bring them through the growing cycle, and they will flower much earlier than natural bulbs. Many hyacinths and some tulips and narcissi are treated in this way. Tazetta narcissi such as 'Paper White' and 'Soleil d'Or'

Crocuses.

Planting bulbs for spring colour

1. Early autumn: cover holes in pots with crocks (pieces of broken clay pot) or coarse gravel to ensure good drainage. Press a layer of moist potting compost lightly into the pot. Use a well-drained compost that is not too nutrient-rich; for example, a home-made mixture based on leaf mould (see page 29).

3. Keep the bulbs cool, dark, and moist, so that they make good roots and the flower bud develops in the bulb just before the shoot grows. For example, stand the pots in a black polythene bag in a cold garage, or put them in a cool shady part of the garden and cover them with leaf mould or sand. Beware of waterlogging and damage by mice.

2. Stand the bulbs closely together on the compost; you only need 2.5–5cm between bulbs. Fill the pots with moist compost, leaving the tips of large bulbs just showing; cover small bulbs with a thin layer of compost. Water and allow to drain thoroughly.

4. Early spring: bring the pots into the greenhouse only when the shoots have made some growth: about 8cm for tall narcissi, 4cm for hyacinths, and 2cm for smaller bulbs. Keep the compost moist but do not get water on the flower buds.

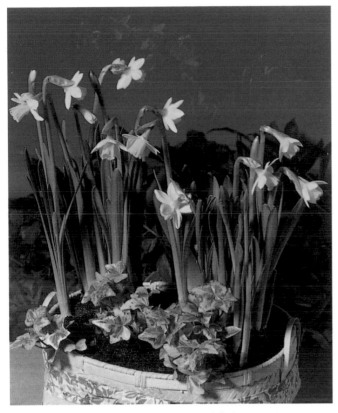

Daffodils in an attractive basket with ivy.

with red, pink, white, or yellow single or double flowers. Start the tubers into growth in early or mid-spring in a heated propagator or on a warm window-sill, laying them hollow-side up on damp potting compost. When shoots appear, pot them up with the top of the tuber just visible. Keep them moist and frost-free. In autumn, when the leaves start to yellow, reduce watering gradually until the tuber is dry. Remove it from the pot and store in a frost-free place.

Nerines produce their flowers in late summer and autumn, before the leaves appear. The common species is pink, but there are other varieties. Pot up bought bulbs in mid-spring in the same way as spring bulbs and put them on the greenhouse bench. Water as necessary as soon as they begin to grow. When the leaves begin to die down in winter, let the compost dry out and keep the pot in a frost-free place. Repot after about three years.

flower naturally in early winter, without the bulbs being prepared or forced in the dark, and they will fill the greenhouse with scent and colour at an otherwise dull time.

Once the flowers have faded, you can put the pots under the greenhouse bench, but keep the compost moist until the leaves start to die. Gradually dry off the bulbs and plant them out in the garden – they will not flower well if grown inside a second time. Tazetta narcissi are not hardy except in very mild areas, but you could plant a few in the greenhouse border if you have room for them to stay undisturbed.

Summer flowering

Tender bulbs and tubers which flower in summer or autumn such as begonias, gloxinia (*Sinningia speciosa*), nerines, and tigridia are good candidates for growing in an unheated greenhouse. They are dormant in winter when the greenhouse is coldest, and are easy to store in a frost-free place indoors. Some hardy lilies, especially the shorter ones, also do well in pots in a greenhouse.

Tuberous begonias flower from early summer to early autumn and are suitable for pots on the staging or in hanging baskets. There are varieties

Tuberous begonias bloom in summer in pots on the staging.

45

Perennial ornamental plants

Some of the most useful plants for an unheated greenhouse are hardy spring-flowering shrubs and climbers, such as camellias, azaleas, and jasmine, and herbaceous plants such as *Dicentra* and pasque flowers *(Pulsatilla)*. Grow these in pots and bring them into the greenhouse in autumn: they will bloom earlier and better than they do outside, where the flowers are easily ruined by frost. In summer, sink the pots in a sheltered, semi-shaded part of the garden to make room for summer plants.

Many popular summer pot plants such as geraniums and fuchsias are not fully hardy, and may not overwinter in an unheated greenhouse. However, they are worth growing for a reliable splash of colour, provided that you have suitable space indoors to keep them during the coldest weather. Alternatively, take cuttings and overwinter small plants in a heated propagator. Similarly, a few chrysanthemum stools overwintered in a frost-free place will provide plenty of cuttings for new plants in spring.

Most foliage plants are also frost-tender, but ivies and some hardy ferns grow well and need not be as dull as you might think!

Climbers are more difficult to move, but slightly tender species such as passion flowers *(Passiflora)* and the scented jasmines *(Jasminum)* could be permanent features if you are prepared to give them space.

Fuchsias and Swan River daisies (Brachycome iberidifolia) *provide a splash of colour.*

Fuchsias

Fuchsias will bloom all summer and well into the autumn. When they start into growth in spring, pinch back the young shoots once or twice to make the plant bushy. In summer, water the plants freely and keep in a lightly shaded, well-ventilated part of the greenhouse. Reduce the amount of water in autumn, and when they have lost their leaves put them in a frost-free place for the winter. Some fuchsia varieties are hardy enough to survive in an unheated greenhouse if the pots are plunged into sand or other insulating material. In spring, pot them into a fairly nutrient-rich potting compost and cut the old growth back by half.

Ivies

Ivies *(Hedera)* can provide a background of foliage at all times of year. Some varieties have deeply cut, heart-shaped or crinkled leaves, others have white, cream, or light-green variegations. They do best when kept shaded from strong sunlight and moved outdoors during the hottest months.

An ornamental ivy (Hedera helix) *trails from its pot.*

Camellias

Camellias have large flowers very early in spring, which may be single or double, in white, red, or shades of pink depending upon the variety. Keep them in large pots or tubs, bringing them into the greenhouse in late autumn and putting them back outdoors in a fairly shady part of the garden after they have flowered. Never let them dry out. Water with rain-water in hard-water areas and use an acid compost when repotting.

Climbing jasmine.

Camellia.

Climbing jasmine

J. polyanthum, sold as a winter-flowering house-plant, is hardy enough for an unheated greenhouse in mild areas. Plant it in a large pot with a tripod of canes or in the greenhouse border. Its tubular white flowers will scent the whole greenhouse in early spring. Cut the plant hard back after flowering to keep it in check. In cold areas choose the summer jasmine, *J. officinale*.

Pasque flowers

Pasque flowers in a greenhouse should give you a display of purple-crimson, pink, or white flowers for early spring. Pot up the plants in a well-drained compost. Keep them in the greenhouse from late autumn until after flowering, then stand them outside in the summer. Avoid overwatering.

Chrysanthemums

Late-flowering chrysanthemums bloom from early autumn onwards, surviving in an unheated but insulated greenhouse until there is a hard frost. In mild areas they could provide you with cut flowers until early winter. When the flowers have finished, cut back all the stems. Keep some of the dormant plants, or stools, to overwinter in a frost-free place, in order to provide plenty of shoots for cuttings the following spring.

Pasque flower.

Chrysanthemums.

Pest and disease control

In the warmth and humidity of the greenhouse, pests can quickly build up numbers, and diseases develop rapidly. Thus, it is essential to keep a close regular watch on your plants and catch any problem before it gets out of hand.

It is also important to identify correctly what is causing the trouble. Sometimes the symptoms of a deficiency or disorder or even a pest attack look more like those of a disease. For example, the sooty mould in the picture below is formed on the sticky secretion exuded by aphids hidden under the leaves, so the aphids are the real culprits.

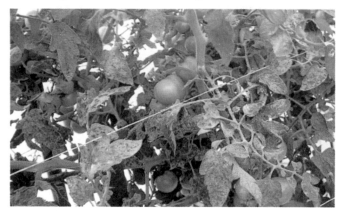

Sooty mould on tomatoes.

Only when you understand a problem will you be able to decide upon which course of action to take to check it and, equally important, to avoid it happening again in the future. Therefore, the emphasis of this section of the book is upon preventing problems. The pests, diseases, and disorders described in detail are ones which are found only in the greenhouse or which are more troublesome there than outside. Many more garden pests and diseases which also attack greenhouse plants are covered in the companion volumes in this series, *Pests: How to control them on fruit and vegetables* by Pauline Pears and Bob Sherman, and *Healthy Fruit and Vegetables* by Pauline Pears and Bob Sherman.

Avoiding problems

First, it is important to select the right plants, matching them to the conditions in the greenhouse. If they are struggling to survive, then they will be very susceptible to pests and diseases. Remember that it is not only temperature that affects them, but factors such as the amount of light, the humidity, and day length. For example, avoid winter crops in a greenhouse that is in shadow when the sun is low in the sky, as they will be weak and lank. Stick to green manures and hardy foliage plants instead.

Pests and diseases will get out of hand more easily if you grow only one type of plant, whether it is tomatoes or fuchsias. Having a mixture of plants – ones from different plant families, annuals and perennials, bushy ones, and ones which trail and climb – makes it more difficult for problems to spread and more likely that pests will be controlled by natural enemies.

Encouraging natural predators

Many greenhouse pests have natural predators which will find their way in through the vents and

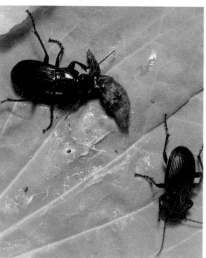

Ground beetles (Carabidae) and frogs are natural predators of slugs.

door provided that the conditions inside are not extreme.

The first step is to encourage these creatures into the garden. Hoverflies, whose larvae prey on aphids, are attracted by simple open colourful flowers which give them an easy feed of nectar. Grow lots of these in the garden and try planting a few in the greenhouse too. Frogs can be encouraged by having a pond in the garden. They will consume large quantities of slugs, reducing the likelihood of these pests coming into the greenhouse, and you may even find that a frog will come to live amongst the damp cool foliage of plants under the staging.

It is also important to be able to distinguish your friends from your enemies. For example, do not squash the ground beetles which scuttle away when you move a big pot, as they also prey on slugs. More information on beneficial creatures and how to encourage them into the garden is given in the companion volume in this series, *Pests: How to control them on fruit and vegetables* by Pauline Pears and Bob Sherman.

Bought-in plants

Greenhouse pests such as whitefly, mealybug, and scale insects rarely find their own way into the greenhouse – it is humans that take them there on plants. Always examine any new plants carefully before putting them in the greenhouse, and keep them in quarantine until you have dealt with any problems.

Resistant varieties

Many breeding programmes are now aimed at finding vegetable varieties which are less susceptible to specific pests and diseases. The individual crop entries indicate which problems might be avoided by growing such resistant varieties. Keep a look out in the seed catalogues as new ones are being introduced all the time.

Greenhouse management

Once you have planted up your greenhouse, success depends upon good management – careful watering, sufficient ventilation, attention to hygiene, and correct feeding. Plants whose basic diet comes from compost, manures, and organic fertilizers rather than from chemicals and liquid feeds will not be so prone to deficiencies or disorders, and they are less likely to produce the lush sappy growth that attracts pests and encourages diseases.

Crop rotation

Crops belonging to the same plant family should not be grown in the same place in the greenhouse border year after year, as this can cause the build-up of soil-borne pests and diseases. Root rots and eelworms, for example, are common problems in greenhouses where tomatoes are always the main crop. Peppers and aubergines belong to the same plant family, *Solanaceae*, as tomatoes, and therefore are prone to many of the same problems. However, you could follow tomatoes with cucumbers or melons. A possible three-year rotation for one border could be:

Year 1 Tomatoes, peppers, and aubergines.

Year 2 Cucumbers and melons.

Year 3 Strawberries and French beans, followed by early winter salad crops.

For a small greenhouse where a rotation is not practical, changing the border soil is an effective if exhausting alternative. In autumn or spring, remove the soil to the depth reached by the plant roots and replace it with good soil from the garden, which has not recently been used to grow similar crops. Do this every two or three years as a precaution, even if you have not seen signs of trouble.

Biological control of common greenhouse pests

Some pests in the greenhouse can be controlled by introducing their natural enemies artificially. A range of such biological controls, which may be predatory insects or mites, parasites, bacteria or fungi, are being used increasingly by commercial growers, and some have also been shown to work well in small garden greenhouses. Good examples are the parasitic wasp *Encarsia formosa*, which controls greenhouse whitefly, and the predatory mite *Phytoseiulus persimilis*, which controls red spider mite.

You can order these controls through the post, and they come in a form which is easy to distribute around the greenhouse. Provided that they have plenty of food and the right conditions, generally they do not try to 'escape', even if you have the doors and ventilators open. More recently introduced biological controls which could be successful in garden greenhouses include nematodes which parasitize vine weevil larvae, and midges which prey on aphids. Details of all these controls are given under the appropriate pest entries. Others, such as the control for scale insect, need higher and more constant temperatures or greater humidity than amateur greenhouses can normally supply, but more may become available in the future.

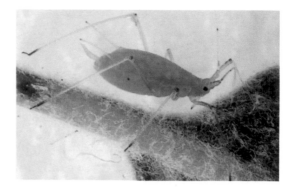

Aphid.

(*Episyrphus balteatus, Syrphus ribesii,* and many other species), lacewings (*Chrysopa* spp.) and ladybirds (*Coccinella, Propylea,* and other species).

Treatment
Examine plants, and even seedlings, regularly. Infested leaves and shoots can be picked off large plants, or the aphids squashed by hand. Use insecticidal or soft soap if all else fails (see page 56).

Biological control
The mite *Aphidoletes aphidimyza* can be introduced into the greenhouse to help control aphids. Its orange larvae, which can just be seen with the naked eye, feed on any aphids they find before falling to the ground to pupate. They are most active at temperatures of 15–20°C, and are best introduced in late spring or summer. If aphid levels are high, then reduce them by spraying first.

Aphids

Many of the hundreds of aphid species, usually referred to as greenfly or blackfly, feed on plants in greenhouses as well as outdoors. They are mainly green in colour and appear first on shoot tips and the under-sides of young leaves. They feed on plant sap, distorting growth and weakening plants, and they can also carry viral diseases. Another problem is the sticky 'honeydew' which they excrete and upon which sooty moulds grow. These look unsightly and can prevent light getting to the leaves.

Prevention
Look after the plants well: those under stress, particularly through underwatering or incorrect feeding, are more susceptible to attack. Encourage the aphids' natural enemies such as hoverflies

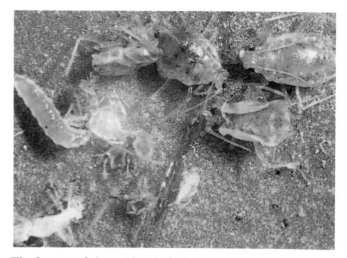

The larvae of the midge Aphidoletes *feeding on aphids. The midge is introduced into the greenhouse as pupae, carried in a material such as vermiculite which is spread on the compost or soil around the base of plants.*

Eelworms or nematodes *Nematodae*

Several species of these microscopic worm-like creatures attack greenhouse plants. Two of the most common examples are given here.

Root knot eelworms *Meloidogyne*

These enter into roots and cause swellings or galls. As a result, the plants become stunted and undernourished, and wilt easily. Plants commonly attacked (although not necessarily by the same species of eelworm) include begonias, chrysanthemums, cucumbers, tomatoes, lettuces, and French beans. The eelworms spread through roots, soil, or potting compost to other plants.

Prevention
Do not introduce suspect plants or soil into the greenhouse.

Treatment
Destroy infested plants and potting compost. Change soil in borders and gravel on staging if likely to be affected. Observe strict hygiene with tools, pots, etc. to prevent spread. For tomatoes, you can grow a rootstock resistant to the eelworm, on to which you can graft other varieties.

Biological control
No biological control available as yet.

Potato cyst eelworms *Globodera*

These enter into the roots of tomatoes, checking growth and reducing yield. The eelworm eggs are contained in spherical brown cysts which you can see with a magnifying glass; these can remain dormant in the soil for up to ten years.

Prevention
Do not introduce suspect plants or soil. Rotate tomato crops in borders, or change the soil regularly, to prevent any cysts present in the soil from building up numbers.

Treatment
Destroy infested plants. Change border soil or grow tomatoes in pots for at least six years.

Biological control
No biological control available as yet.

Glasshouse whitefly *Trialeurodes vaporariorum*

These tiny white moth-like insects live on the under-sides of leaves of many greenhouse plants, flying off when disturbed. Both the adults and the immobile white scales, which are their immature form, feed on plant sap. They secrete honeydew upon which unsightly sooty moulds form, and heavy infestations can weaken plants. Whitefly overwinter on plants and weeds in the greenhouse, their eggs surviving even if it is not heated, and they begin to multiply rapidly once temperatures get over 15°C.

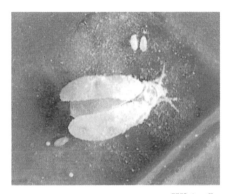

Whitefly.

Prevention
Examine newly acquired plants thoroughly to avoid bringing in whitefly. Clear weeds and old annual plants out of the greenhouse in autumn to help prevent the pest from overwintering. Treat or destroy any other infested plants.

Treatment
Yellow sticky traps will control small numbers of whitefly and give you an early indication that they are present. For larger numbers, try shaking the plants and using a portable vacuum cleaner to suck up the adults as they fly. As a last resort, spray with insecticidal soap (see page 56).

Yellow sticky panels designed to attract and trap flying insect pests. Use them as a warning that pests are present before noticeable damage occurs. They can also help to control small numbers of whitefly, but do not leave them up if you are trapping too many beneficial insects, or if you introduce Encarsia biological control.

51

Biological control
The parasitic wasp *Encarsia formosa* lays eggs inside the whitefly scales. These turn black as the eggs develop, and new adult wasps emerge. Introduce the control two to three weeks after you see the first whitefly, but before numbers build up. Reduce numbers by spraying if necessary. The wasp works best at temperatures of 18–27°C, usually reached in an unheated greenhouse by late spring or early summer, and once established it should keep whitefly below damaging levels for the whole season.

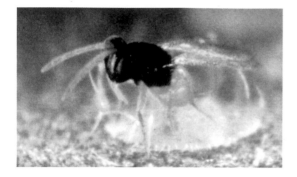

The parasitic wasp Encarsia formosa *is used to control greenhouse whitefly. Its eggs, contained in parasitized whitefly scales, are supplied on cards which are hung around the greenhouse on infested plants.*

Leaf miners, chrysanthemum *Phytomyza syngenesiae*

The leaf miners commonly troublesome in the greenhouse are small flies which lay their eggs inside plant leaves. The larvae which hatch eat out meandering tunnels, spoiling the appearance of the plants. Chrysanthemums and lettuces are amongst the plants commonly affected.

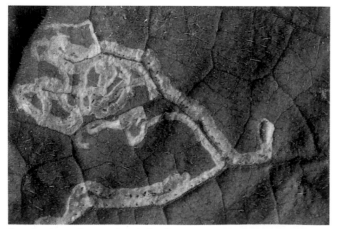

Leaf miner damaging a leaf.

Prevention
The larvae can overwinter on weeds such as sowthistle and groundsel, so make sure that you remove these from the greenhouse and garden if this pest is a problem.

Treatment
Inspect plants regularly and pick off affected leaves as soon as you see them.

Biological control
No biological control available to amateur gardeners as yet.

Mealybugs *Pseudococcus obscurus*

These scale-like wingless insects are covered with a powdery white protective wax. They feed on the sap of many greenhouse plants, amongst the most susceptible being vines, begonias, cacti, chrysanthemums, and fuchsias. They cause leaves to yellow, and unsightly sooty moulds form on the sticky honeydew that they secrete.

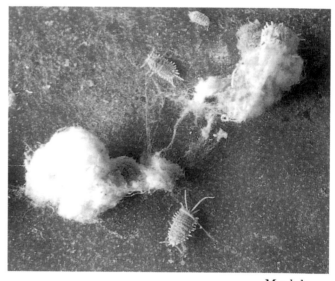

Mealybugs.

Prevention
Mealybugs almost always come in on plants, so examine any new ones carefully before putting them in the greenhouse.

Treatment
Cut out heavily infested shoots. Hose large sturdy plants with a strong jet of water. As a last resort, spray with insecticidal soap (see page 56). Remove mealybugs from small delicate plants with a paintbrush dipped in surgical spirit or insecticidal soap.

Biological control
A predatory beetle, the ladybird *Cryptolaemus montrouzieri*, is marketed to commercial growers to control mealybug, and could be used in amateur greenhouses during the summer months.

Tomato moth *Lacanobia oleracea*

The yellow-green or brown caterpillars of this moth eat holes in leaves and fruits of tomatoes, and may attack other greenhouse plants as well as tomatoes, although damage is rarely severe. The caterpillars pupate in cocoons on walls, woodwork, or plant debris.

Prevention
Clean out the greenhouse thoroughly in autumn to destroy overwintering pupae.

Treatment
Seek out and destroy caterpillars if damage is seen.

Biological control
Very bad attacks could be controlled by spraying with a formulation of the bacterium *Bacillus thuringiensis*.

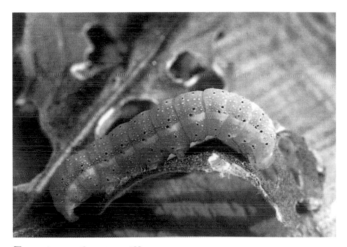

Tomato moth caterpillar.

Red spider mites *Tetranychus urticae*

The first signs of this pest are a light mottling of affected leaves. Look underneath them with a magnifying glass and you should see the tiny mites which, despite their name, are usually greenish in colour; only the overwintering females are bright red. Many greenhouse plants are susceptible to attack including cucumbers, aubergines, fuchsias, and strawberries. If pest numbers build up, then the leaves become more discoloured and the plants become covered in a fine white webbing.

The mites breed from spring to autumn, particularly encouraged by hot dry conditions. From early autumn onwards, the females find sites to hibernate, e.g. in cracks and crevices, under dead leaves, and in potting mixtures.

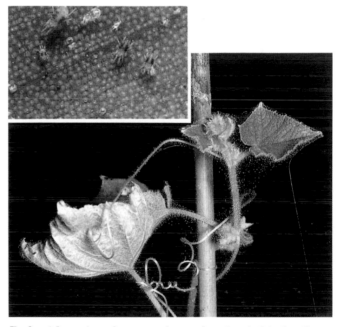

Red spider mites damage plants, leaving behind a fine silk webbing.

Prevention
Provide good growing conditions, as vigorous plants are less likely to be attacked. Spray susceptible plants with water when it is hot and dry, and do not let them dry out. Clean out the greenhouse thoroughly in autumn (see page 15).

Treatment
Insecticides are not usually very effective, but as a last resort try derris (see page 56).

53

Biological control

The slightly larger mites *Phytoseiulus persimilis* eat red spider mites in all their stages. These predatory mites multiply rapidly at temperatures of 20–30°C, and when all the red spider mites have been consumed *Phytoseiulus* will rapidly die out.

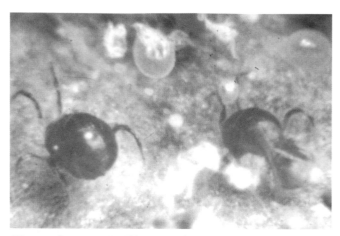

The predatory mite Phytoseiulus persimilis *is used to control red spider mite. The mites are supplied either on leaves or in a material such as vermiculite, which can be spread around the greenhouse.*

Sciarid flies *Lycoriella*

These small black flies, often called mushroom flies or fungus gnats, are attracted by the smell of decaying organic matter. They hover around plants in pots and trays, and lay their eggs in the compost. Many species are harmless, but the larvae of some feed on young roots. Seedlings and cuttings can be killed and older plants weakened by severe attacks. Look out in the compost for white maggots 4–6mm long with shiny black heads.

Sciarid fly.

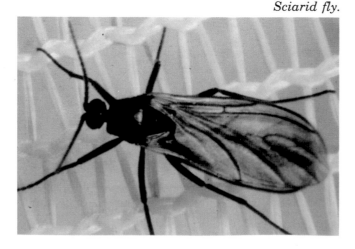

Prevention

Remove any dead plant matter from the greenhouse before it has a chance to rot. Use well-drained seed and potting composts, and do not overwater plants as those in waterlogged conditions are particularly susceptible to attack. Covering the surface of the compost in a pot with horticultural grit will help deter the flies from laying their eggs.

Treatment

Repot affected plants in fresh compost, destroying any larvae that you see.

Biological control

The same or similar control to that used against vine weevil larvae is also effective against sciarid larvae.

Scale insects, soft scale *Coccus hesperidum*

The species of these insects usually found in greenhouses are covered with roughly hemispherical brownish waxy scales. They live mainly on the under-sides of leaves alongside the veins, and on plant stems. They attack many ornamental plants, particularly those with shiny leaves such as bays and camellias, and also peaches and vines. Like aphids, they feed on sap, weakening the plants, and excrete sticky honeydew upon which sooty moulds grow. The adult scales rarely move, but lay eggs under the scales from which young 'crawlers' hatch. These move over the plants before settling to feed and forming their own protective scales.

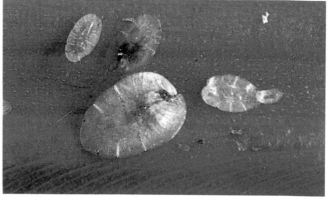

Scale insect.

Prevention

Scale insects are generally brought into the greenhouse on plants, so examine any new ones carefully.

Treatment

Remove scales from plants with relatively robust leaves by wiping them off, using a cloth or soft

toothbrush dipped in soapy water. Crawlers can be sprayed with insecticidal soap (see page 56) – if you can catch them. They are most likely to hatch during late spring and early summer, although they could be about during any warm spell. You need a magnifying glass to see them.

Biological control
No biological control widely available to amateur gardeners as yet.

Vine weevil *Otiorhynchus sulcatus*

The legless white larvae of this weevil feed on the roots, corms, and tubers of many plants. This checks their growth and often causes them to wilt suddenly. Cyclamen, primulas, and begonias are particularly susceptible but other pot plants are often affected. The adult weevils hide at ground level during the day; they cannot fly, but at night crawl up on to plants and eat holes in the leaves. They lay eggs in the potting compost, mostly in spring and then again in midsummer. The larvae hatch a few weeks later.

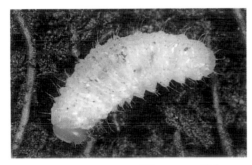

Vine weevil larva.

Prevention
Remove any debris that could harbour adult weevils. Inspect plant roots when repotting and destroy any larvae you see. Plants in pots on greenhouse benches can be protected with a band of non-hardening glue, sold for catching crawling pests.

Treatment
Examine the roots of wilting plants immediately; destroy larvae and repot into fresh potting compost.

Biological control
Nematodes (*Steinernema sp.* or *Heterorhabditis sp.*) which parasitize vine weevil larvae can be watered on to pots and soil. These microscopic creatures enter the body of the pest and multiply within it, killing it within a few days. Further nematodes are thus released which will move around in the soil or

compost provided that it is kept moist. The control is best applied either in mid to late spring or in late summer, which are the periods when most weevil larvae are active. It is most effective at temperatures above 20°C.

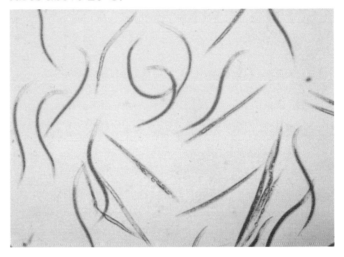

Parasitic nematodes.

Woodlice *Oniscus*, *Porcellio*, and *Armadillidium*

These familiar garden creatures usually feed on decaying organic matter, but in greenhouses they may eat seedlings at soil level and chew the leaves, fruit, and roots of older plants. They hide and breed in moist cool places.

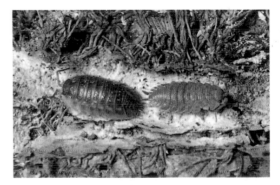

Woodlice.

Prevention
Keep the greenhouse clear of any type of debris which could provide the woodlice with refuge. Sticky bands as used for vine weevil could prevent woodlice reaching plants in pots.

Treatment
Kill woodlice found under bricks, stones, and debris with boiling water. Leave one or two such

hiding places as traps for survivors and keep checking them. You can also buy traps for woodlice, which are baited with a pheromone (a synthesized sex attractant).

Biological control
No biological control available as yet.

Organic sprays against pests

The sprays listed here are generally of natural origin and should cause less persistent damage in the environment than many chemicals. Nevertheless they are not harmless. They may kill beneficial insects and harm creatures other than the pest. Only use them as a last resort, and take as much care to make up the correct dilutions, and avoid spillage and spray drift, as you would with any chemical.

DO NOT:
• Use a spray agent against pests other than those for which it is intended.

• Spray plants when bees or other pollinating insects are working.

• Spray after you have introduced biological controls into the greenhouse, unless you are sure that you are not harming them.

• Spray in bright sunshine, as you could scorch plant leaves.

• Spray when it is cold or damp, or when you cannot ventilate the greenhouse, as this will encourage fungal diseases.

Derris
Effective against
Aphids, red spider mite, caterpillars. Kills mainly on contact, therefore spray directly on to the pest.

Cautions
Poisonous to fish and harmful to some beneficial creatures including ladybirds.

Insecticide soap
Effective against
Aphids, whitefly, red spider mite, scale insects. Spray directly on to the pest.

Cautions
Can harm some beneficial creatures including ladybirds and their larvae. Can damage sensitive plants, e.g. ferns, so do a small spot test before spraying the whole plant.

Pyrethrum
Effective against
Aphids and small caterpillars.

Cautions
Poisonous to fish. Harmful to some ladybirds. Many brands of pyrethrum also contain piperonyl butoxide, and these are now accepted as organic sprays.

Soft soap
Effective against
Aphids, spraying directly on to the pest. Also used as a wetter to help other sprays stick. Not approved as a pesticide in the UK.

Common diseases of greenhouse plants

Damping off
Various fungi and bacteria, *Pythium sp.*, *Phytophthora*, and others which are common in garden soils contribute to this problem. Seedlings topple and die, often in circular patches; the stems sometimes shrivel or discolour near soil level. Seedlings of bedding plants such as antirrhinums, lobelia, and petunias are particularly susceptible, although many others are often affected. The problem is worse in damp, cold, overcrowded conditions.

Prevention
Clean pots and seed trays thoroughly. Use a good seed compost: one which drains well and is free from disease organisms. Sow thinly, and give seeds sufficient warmth and ventilation. Do not water susceptible seedlings from water-butts.

Treatment
None. Dispose of infected seedlings and do not reuse contaminated seed compost.

Downy mildew
This is an off-white mould occurring in cool damp conditions, caused by *Peronospora* and *Bremia* fungi. Winter lettuce is the plant most commonly affected in greenhouses; pale patches appear on the surfaces of leaves with corresponding patches of mould on the under-sides. Resting bodies of the fungus can survive in the soil and crop debris.

Downy mildew on lettuce.

Prevention
Rotate lettuce crops or change border soil. Ventilate the greenhouse well. Do not let seedlings or plants get overcrowded and keep water off the leaves. Look out for resistant varieties.

Treatment
Remove infected leaves as they appear and clear out plants and debris after harvest.

Grey mould

A distinctive fluffy grey mould, *Botrytis cinerea,* affects many greenhouse plants. For example, it commonly develops on the leaves and fruit of cucumbers, beans, lettuces, tomatoes, strawberries, and vines, and on the flowers of chrysanthemums. The fungus exists widely on dead or dying plant material and spreads by spores which are often released in clouds when the mould is touched. Infection is worse in cool, damp, overcrowded conditions.

Grey mould on a strawberry.

Prevention
Avoid overcrowding plants, and ventilate the greenhouse well. Do not grow susceptible plants at low temperatures. Good hygiene is essential, particularly picking off dead or damaged flowers and leaves. A few varieties of lettuce and strawberries have some resistance.

Treatment
Remove and destroy affected leaves immediately.

Powdery mildew

This is a powdery white coating, caused by *Sphaerotheca, Oidium, Uncinula,* and other fungi, which can cover almost any part of the plant. Susceptible greenhouse plants include cucumbers, strawberries, vines, and chrysanthemums. However, the disease will not spread between them, for example from cucumbers to vines, as there are many different powdery mildew fungi each with a limited range of host plants. All powdery mildews are worse in hot, dry, overcrowded conditions. Their spores spread in the air, and usually overwinter on crop debris.

Powdery mildew on a leaf.

Prevention
Ensure adequate ventilation. Do not overcrowd plants, and keep them well watered. Clear out all plant debris at the end of the season. Look out for resistant cucumber varieties.

Treatment
A spray of bicarbonate of soda solution has been used to control many powdery mildews. Sulphur is a traditional organic remedy, but many greenhouse plants are damaged by this chemical.

Potato and tomato blight

The spores of this widespread potato disease (*Phytophthora infestans*) can be blown into the greenhouse in warm humid weather and infect tomato crops. It causes dark blotches on the leaves, sometimes with a white mould on the under-sides, and a dryish brown rot on the fruit.

Potato and tomato blight.

Prevention
Take precautions to avoid blight on your potato crops, and remove any infected potato foliage.

Treatment
There is no cure.

Root and foot rots

Symptoms of wilted leaves and blackened or decayed roots can be caused by a wide variety of fungi. They are nearly all soil- and water-borne, and ways of avoiding them and treating them are the same. Susceptible greenhouse plants include cucumbers, lettuces, strawberries, tomatoes, chrysanthemums, and primulas. Plants under stress are more susceptible.

Prevention
Keep plants growing strongly. Do not use unsterilized soil in potting compost or reuse old potting compost if either is likely to be contaminated. Rotate crops in borders or change the soil regularly. Scrub out water-butts.

Treatment
None. Remove and destroy infected plants.

Viral diseases

There are many viruses which affect greenhouse plants, often causing symptoms such as stunted and/or distorted growth, mottling of the leaves, and streaked flowers. These symptoms are easily confused with those caused by deficiencies and disorders (see pages 59–62). Viral diseases can be spread from plant to plant in a number of ways: by aphids and other sap-sucking insects; by contact with infected foliage, tools or hands; in the soil; or sometimes in seed. A few common examples are given here, but the methods of prevention and treatment are similar for them all.

Prevention

Never take cuttings or save seed from diseased plants. Use resistant varieties if available. Control creatures such as aphids that may pass on the virus. Remove weeds and clear old plants as soon as harvesting is over.

Treatment
None. Remove the infected plants completely and avoid contaminating healthy plants from hands, pots, tools, etc.

Cucumber mosaic virus
Mosaic patterning forms on leaves of cucumbers and courgettes, and sometimes fruit becomes distorted. Other plants commonly affected include lettuces, tomatoes, begonias, and *Primula*, and the virus is also carried by chickweed (*Stellaria media*). It is transmitted mainly by aphids, but also by contact and possibly by seed. Look out for resistant varieties.

Tobacco mosaic virus
This causes leaf mottling and often wilting of young tomato leaves. Some (but not all) leaves may also become puckered or dwarfed. Brown patches develop beneath the surface of green fruit. The virus also affects *Nicotiana*, peppers, petunias, and potatoes, and can be carried in tobacco. It is very infectious, and is spread by contact and seeds but not by aphids. Look out for resistant varieties of tomatoes and peppers.

Tomato aspermy virus
This is common on chrysanthemums, causing small ragged blooms, and will also infect tomatoes, which become bushy with mottled leaves and small fruit. It is spread by aphids.

Wilts

Most wilts on greenhouse plants are caused by *Verticillium* or *Fusarium* fungi. The plant's lower

Plant in centre of cucumbers is dying of wilt.

leaves are the first to wilt, and later they yellow and shrivel. There is a characteristic brown stain in the stem when it is cut well above ground level. Cucumbers, courgettes, French beans, tomatoes, strawberries, begonias, chrysanthemums, and fuchsias are amongst the most susceptible greenhouse plants. The disease can persist in the soil for several years.

Prevention
Do not raise plants too early, or plant them out into cold soil or compost. Rotate crops or change the border soil regularly.

Treatment
Plants not severely infected may recover if given warmer, shadier conditions; earth the stems up with fresh compost or leaf mould. Remove and destroy infected plants and potting compost. Change border soil. Thoroughly wash pots and any contaminated tools, etc. Look out for resistant varieties of tomato.

Organic sprays against diseases

Bicarbonate of soda

Effective against
Powdery mildew, as both a preventive and a cure. Suggested dilution: 5g per litre with a wetter such as soft soap at 10g per litre.

Cautions
This familiar household substance appears to be harmless to insects and plants, although badly mildewed leaves will turn black after they have been sprayed. Use not approved in the UK.

Nutrient problems

Shortages or excesses of one or more plant foods can cause a variety of symptoms, from generally poor growth to vivid colouration of the leaves. Such imbalances are more likely to occur in greenhouse plants because they are often growing quickly and being fed from a small volume of soil or compost. Also, there is no rain to wash out nutrients that the plants do not use. An excess of a particular nutrient can be harmful in the following ways:

• It can be directly toxic to plants.

• It can be taken up by the plant in preference to other nutrients, even though they are present in the soil or compost, and hence cause deficiencies.

• It can make the general level of salts in the soil or compost too high, which has various detrimental effects (see below).

A pH which is too high or too low can also cause nutrient imbalances. The causes of such problems are difficult to identify and to correct, and only a few of the most common are listed here. The best solution is to avoid them in the first place by careful preparation of the greenhouse border and judicious feeding (see pages 16–18).

Nitrogen deficiency

Symptoms
Poor growth; leaves turn pale (older leaves first), and sometimes have purplish tints. Almost any greenhouse plant can be affected, and those growing in pots are particularly susceptible.

Nitrogen deficiency of strawberries.

59

Treatment
IMMEDIATE Use a liquid feed.
LONGER TERM Repot pot-bound plants, or top-dress them with worm compost or organic fertilizers. Mulch plants in borders with grass mowings or well-rotted manure.

Nitrogen surplus

Symptoms
Lush soft growth, especially in low light levels. Foliage produced at the expense of flowers.

Treatment
Keep plants well watered and do not feed them until growth becomes normal.

Magnesium deficiency

Symptoms
Yellowing between leaf veins, on oldest leaves first. Plants exposed to strongest sunlight are often the first affected. Tomatoes are particularly susceptible, but note that the natural aging of the lower leaves gives similar symptoms. Excess potassium makes magnesium unavailable.

Treatment
Reduce the use of comfrey or other high-potassium feed. Foliar feed fortnightly with a 2 per cent solution of 10 per cent Epsom salts.

Iron deficiency.

Iron deficiency

Symptoms
Leaves bleach yellow between the veins, youngest leaves first. Common on acid-loving plants, such as azaleas and camellias. Tomatoes sometimes affected. The problem is usually caused by a high pH which makes iron unavailable.

Treatment
Repot pot plants into acid compost and water them with rain-water if tap water has high pH. Check pH of border soil.

Calcium deficiency

Symptoms
Scorching of leaf margins of lettuce, youngest leaves first. Blossom end rot of tomatoes and peppers (a round brown patch at the bottom of the fruits). These symptoms are usually due to calcium being unavailable to plants, or being unable to move to the

Blossom end rot on tomatoes.

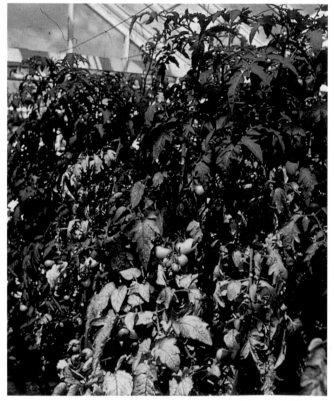

Magnesium deficiency.

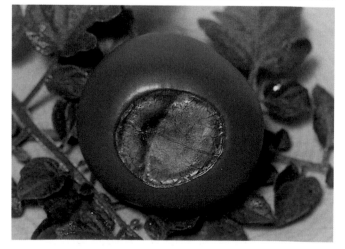

young tissues, rather than to any lack of it in the soil or compost. Lack of water, high humidity, excess potassium, or a high salt level in the compost (see below) can all contribute to the problem.

High salt level

Symptoms
Poor growth, yellowing of leaves, burning of leaf margins, roots going brown and shrivelling. If the salt level (the concentration of soluble nutrients) in the soil or compost is too high, then plants will take up too many nutrients and not enough water. Seedlings, bulbs, and lettuce are amongst the plants most susceptible to damage. Tomatoes and chrysanthemums are amongst the most tolerant. The effect is worse if the plants are allowed to become dry, and may also be exaggerated if the pH of the soil or compost is very high or very low. Compost ingredients such as manure, worm compost, comfrey, and blood, fish and bone, which contain the most readily available nutrients, have most effect on the salt level.

Treatment
IMMEDIATE Stop using liquid feeds. Remove any mulches of manure, worm compost, etc. Remove any loose potting compost from plants in pots and repot them in fresh compost. Water plants beyond the saturation point of the soil or compost to leach out excess nutrients.
LONGER TERM Reduce amounts of nutrient-rich materials added to compost or borders, and check the pH. Flood border soils before planting a new crop, applying 20–30 litres of water per sq m over a period of four to five days. Grow a green manure such as grazing rye over the winter (see page 18).

Grazing rye, a useful green manure for the long-term treatment of high salt levels.

Disorders

Lack of moisture in the soil

Symptoms
Dullness of leaves followed by wilting; blossom end rot of tomatoes and peppers (see calcium deficiency on opposite page).

Prevention
Keep plants well watered at all times, and use a moisture-retentive potting compost. Add organic matter to borders.

Lack of moisture in the air

Symptoms
Leaves may brown or scorch, and fruit remains tiny (especially on tomatoes). Pot plants shed buds and flowers.

Prevention
Spray plants with water in morning and evening.

Waterlogging

Symptoms
Yellowing of leaves, stunted growth; root rots encouraged.

Prevention
Reduce watering. Use well-drained potting compost, and add organic matter to heavy border soils.

High temperatures

Symptoms
Scorch of leaves, often resulting in brown papery patches; tomato fruit may develop hard green areas (greenback). The leaves may curl if the temperature is very high, or fluctuates greatly between cool night temperatures and hot day ones.

Prevention
Ensure adequate ventilation and shading (see pages 12–13). Damp down the greenhouse in hot weather. Do not strip leaves from tomatoes and expose the fruit; some varieties have resistance to greenback.

Damage from paraffin or gas heaters

Symptoms
Fumes from oil or gas heaters can cause dry brown areas on leaves. The small amount of sulphur dioxide produced when paraffin is burnt can affect sensitive plants such as tomatoes and salvias. Low levels of other pollutants (usually oxides of nitrogen and ethylene) can affect the growth of a wide range of plants, even if there is no visible damage.

Leaf curl on tomatoes, possibly caused by too high a temperature.

Prevention
Burn premium-grade paraffin sold for room and greenhouse heaters. Use a blue-flame rather than a yellow-flame heater if you want a heat output higher than 1kW. Keep the greenhouse ventilated when the heaters are in use. Make sure all gas and paraffin heaters are serviced regularly.

Glossary

Annual: a plant which grows from seed, flowers, and dies all in one year.

Biennial: a plant whose life is spread over two growing seasons; leaves grow in the first; flowers appear in the second; the plant then seeds and dies.

Brassica: a member of the plant family which includes cabbages, Brussels sprouts, cauliflowers, kale, turnips, swedes, salad rape, and Oriental greens and mustards.

Chrysanthemum stool: a chrysanthemum plant after it has flowered and its stems have been cut back; used to produce cuttings the following spring.

Cucurbit: a member of the plant family which includes cucumbers, marrows, courgettes, pumpkins, and melons.

F1 hybrid: a vegetable or flower variety produced by crossing two selected pure-breeding parent varieties. F1 hybrids are uniform, vigorous, and high-yielding.

Half-hardy annual: an annual plant that will not tolerate frost.

Honeydew: sticky, sugary liquid produced by greenfly and other sap-sucking insects.

Horticultural fleece: fine white polyester material, used on crops for protection against frost or pests.

Larva (plural larvae): many insects go through several different stages in their life, starting out as eggs which hatch into larvae. These are often greedy-feeding legless grubs: caterpillars, for example, are the larvae of butterflies, moths, and sawflies.

Leaf mould: decomposed leaves.

Mulch: any material spread over the surface.

Organic: a method of growing plants which avoids the use of chemical pesticides and artificial fertilizers. Organic methods aim to minimize disruption of the natural environment.

Perennial: a plant that lives for three or more years.

pH: a measure of the acidity of the soil. A pH of 7 is taken to be neutral; a soil with a pH of less than 7 is acid, whilst one with a pH of more than 7 is alkaline.

Pupa: the stage of an insect between larva and adult. Pupae are usually immobile and do not eat.

Residual current device: a device that breaks the electrical circuit very quickly when a fault occurs.

Seep hose: a pipe, laid on the the surface of the soil or just underneath it, that allows water to leak out slowly along its length.

Sooty mould: a soot-like fungus that grows on honeydew.

Trace elements: minerals which are needed by plants in minute amounts, but which are nevertheless essential to their health.

Worm compost: the material produced when brandling worms eat their way through organic material such as kitchen waste. You can set up a worm bin yourself to make worm compost, or buy bags of worm-casts.

Index